Magic Lantern Guides

Canon
EOS *ELAN*
EOS 100

Steve Pollock

Magic Lantern Guide to
Canon EOS Elan/100

A Laterna magica® book

English Language Edition 1995
Published in the United States of America by

Silver Pixel Press
Division of
The Saunders Group
21 Jet View Drive
Rochester, NY 14624

Written by Steve Pollock

Printed in Germany by Kösel GmbH, Kempten

ISBN 1-883403-21-9

Contents

Introduction

Canon has produced many innovative cameras in their EOS series aimed at a wide variety of photographers. Of these, the EOS Elan/100 is a comparatively advanced mid-range model, suitable for users from novice to professional status. With careful design, the complexity and sophistication of the Elan/100 been harnessed to make camera operation as simple as possible. In particular, the Elan/100's controls are sensibly arranged and accessible, so they serve as a bridge rather than a barrier between the photographer and the image.

Camera manufacturers continue to add additional features to each new camera model, yet very few photographers are likely to use every feature contained in today's electronic wonders. Users discover that they employ some features and functions on their cameras often and others seldom or never. Also, needs change as time passes, so the way a camera is used today is not necessarily the way it will be used next year. This is especially true of the photographer buying his or her first single-lens reflex (SLR) camera.

It is probably best for the beginner to keep the Elan/100 in its fully-automatic modes (identified as the Image Zone) until confidence is developed. Then you can experiment with additional features, preferably one at a time. A few rolls of film should prove how easy it is to photograph with the EOS Elan/100 while establishing a rapport between photographer and camera. This book can be referred to again and again during this learning period as the photographer's knowledge of the camera continually increases.

We invite you to use this publication as an instruction manual and more. Not only will it explain how the Elan/100 works, it will also detail the reasons why the various functions are included, when they are needed and the basic photographic principles involved. It is not essential that the photographer know every aspect of photographic art and science to produce great pictures. However, with a basic understanding of the theories of photography, images that are well-exposed and well-composed will be the norm rather than a surprise.

Note: *Essentially the same camera is called the EOS Elan in North America and the EOS 100 in other world markets. The minor differences are explained where appropriate in the text. Otherwise, features and functions described throughout the book apply to both EOS models, which are therefore referred to as the Elan/100.*

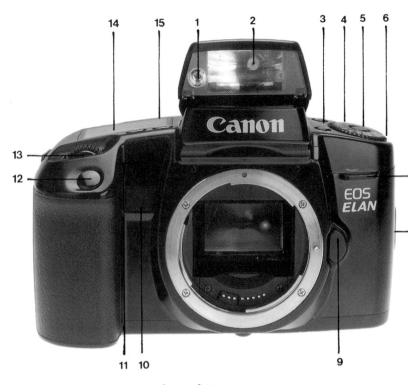

Operating Controls and Features

1. Red-eye reduction lamp
2. Built-in flash
3. Flash on/off
 Red-eye reduction select button
4. Metering mode/Built-in flash exposure compensation select button
5. Lock release button
6. Command dial
7. Strap fixture
8. Back cover latch
9. Lens release button
10. Remote control receiver
11. AF assist light/Self-timer & remote control indicator
12. Shutter release
13. Electronic input dial
14. AF mode selector
15. Film transport mode selector

16. Accessory shoe
17. X-sync contact
18. LCD panel
19. AE Lock/Custom function
 select button
20. Strap fixture

21. Bar code input terminal
22. Manual rewind button
23. Quick control dial
24. Quick control dial on/off
25. Film window
26. Viewfinder

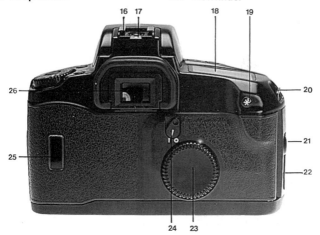

27. Film transport mode selector
28. AF mode selector
29. Electronic input dial
30. Strap fixture
31. LCD panel
32. Accessory shoe
33. X-sync contact
34. Metering mode/Built-in
 flash exposure compensation
 select button

35. Command dial
36. Lock release button
37. Strap fixture
38. Flash on/off
 Red-eye reduction select
 button

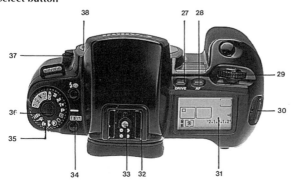

Camera Basics

The Canon EOS Elan/100 is a highly sophisticated autofocus SLR, capable of producing professional-quality results. It incorporates a range of electronic, mechanical, and optical innovations which may seem intimidating at first glance. Rest assured, however, that everything is there for a reason. With a little study, you will soon master the Elan/100's control layout and even come to appreciate its more subtle features.

Getting Started

Neckstrap

For safety's sake, your first operation is to attach the neckstrap. This is done by slipping the strap through each of the two rectangular rings on the camera body. Adjust the length so that the Elan/100 hangs comfortably, which usually means at stomach level. And be certain both ends of the strap are securely threaded through the provided buckles. That will help prevent dropped-camera disasters.

Battery

The next step is to load the 6-volt lithium 2CR5 battery. To do this, you slip open the latch on the battery-compartment cover, located on the bottom of the camera. Insert the battery so that its metal terminals go in first. (The battery will also fit in the compartment upside-down, but the camera won't operate.) Now close the cover, making sure that the latch locks with a slight "click."

Because the Elan/100 is shipped with the Command Dial in the "L" (locked) position, the top-deck LCD panel is blank except for two rectangular outlines. To make sure your battery is okay, press the Lock Release Button in the center of the Command Dial and

Setting the camera for automatic operation allows the photographer to concentrate completely on the subject and composition. Photo: Bob Shell

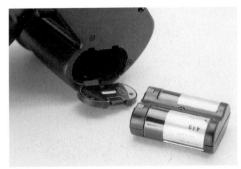

On the bottom of the EOS Elan/100 is the battery compartment which accepts a 6-volt lithium 2CR5 battery.

rotate the dial to the green rectangle (Full Auto) symbol. The LCD panel will now come to life, including a battery-condition symbol. The symbol normally shows a whole battery; a half-battery symbol means the battery is weak; an empty battery symbol means it is nearly dead.

If the battery symbol blinks, either the battery is exhausted or the camera has an internal malfunction. Turn off the camera, remove the battery, clean the terminals with a pencil eraser, and put the battery back in. Now turn on the camera and release the shutter. If the blinking symbol persists, replace the battery with a new one and repeat this process. In the unlikely event that the blinking persists, take the Elan/100 to your dealer or to a Canon authorized service center.

Mounting the Lens
Your Elan/100 may already have a lens mounted. If not, remove the rear cap from the lens by turning it counter-clockwise. Then remove the body cap by turning it the same way. To mount the lens, align the red dot on the lens with the one on the camera body, then rotate the lens clockwise until it clicks into place. Be sure to set the Focus Mode Switch on the lens to AF, for autofocus operation.

Film Loading
To load film, open the camera's back cover by sliding down the Back Cover Latch on the side of the body. Place the film cartridge in the chamber on the left and pull out the film leader until it reaches the orange mark. When you close the back cover, the film will automatically load and advance to the first frame, indicated

14

Insert the film into the film cassette chamber and pull the leader to the orange line on the lower right side of the camera.

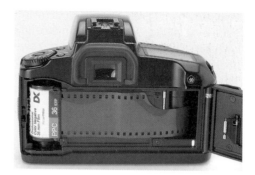

by a "1" on the LCD panel. If the film-cartridge symbol blinks, the film has not loaded properly. Note that the film will rewind automatically at the end of the roll; the blinking-cassette symbol means that it is fully rewound. You can also rewind film mid-roll, by pressing the recessed Film Rewind Button on the camera's side.

The vast majority of modern film cartridges are coded with the "DX" system, which automatically tells the Elan/100 the exact ISO film speed to set. If a non-DX coded cassette is loaded, the Elan/100 will remain set to the previous ISO value. As a warning, the ISO will blink on the LCD panel, but unless you manually input the ISO value, you run the risk of having incorrect exposures. (See page 67.)

Multi-Purpose Shutter Button

The large, soft-touch button on the Elan/100's hand grip controls the focusing and exposure systems, and releases the shutter as well. To do all this, the Shutter Release Button operates in two

Located inside the film cassette chamber are six sensors which read the film's DX-coding and automatically set the film speed.

steps. When you press the button partway in, to the first point of resistance, the Elan/100 focuses on the subject and determines the f/stop and shutter speed for proper exposure. Push the button the rest of the way in and the exposure is taken; then the film immediately winds to the next frame. When shooting quickly, you can push the shutter button in one smooth stroke. All these functions are performed automatically and virtually simultaneously.

You will notice a set of brackets in the viewfinder which indicate the subject area that the AF system is "reading." The In-Focus Indicator Light, in the illuminated panel below the picture area, glows steadily when the subject is properly focused. If this light blinks, the AF system is unable to establish focus and the camera will not fire. Next to this light are LCDs that display the chosen f/stop and shutter speed; these numbers also appear on the top-deck LCD panel. Like the AF setting, these exposure values will be held until you either take your finger off the shutter release button or take the picture.

A camera-shake symbol appears below the picture area and blinks if the required shutter speed is lower than the reciprocal of the lens focal length (e.g. below 1/30 second for a 28mm lens or equivalent zoom position). Nonetheless, the picture can still be taken. On the EOS Elan, a lightning-bolt symbol will also blink to suggest that you use the built-in flash. The EOS 100 flash pops up automatically for low-light subjects. When you let go of the shutter release button, the LCD panel remains lighted for about six seconds.

Holding the Camera

Just as important is the way an SLR camera is held. The most stable position is to cup the camera in your left hand, bracing your arm against your body. This allows you to change aperture settings and focus with your fingers (for a horizontal or vertical shot) without having to release the camera from its cradle in your left hand. This leaves the right hand free to advance the film and press the shutter release button with steady, even pressure. Select a grip that is comfortable, but be sure that it does not interfere with the camera's operation. For example, do not hold the lens in a manner that would interfere with the autofocus mechanism, and be careful not to block the flash with your hand.

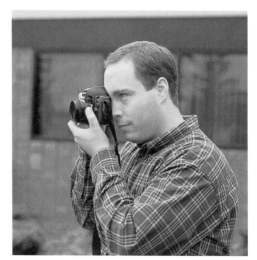

Proper handholding technique is important to minimize camera movement. The right hand holds the camera grip and releases the shutter while the left hand supports the camera from below and controls manual focus. Keep both elbows close to the body for stability.

Exposure Fundamentals

Whether manual or automatic, the most essential of all camera controls are for manipulating the amount of light that reaches the film. After all, photography is nothing more than light reflected off a subject and recorded on film. As with most cameras, the EOS Elan/100 uses two mechanisms for regulating the amount of light to hit the film. The shutter, located in the body of the camera, is essentially a door that opens to control the amount of time the film is exposed to light. The aperture is an "iris-like" mechanism in the lens which can be adjusted to regulate the amount of light that hits the film. This mechanism is similar to the functioning of our eyes; our pupils open and close depending on the amount of light. When taking a picture, either the shutter speed or the aperture or both can be adjusted. By doing so we increase or decrease the film's exposure to light. In this manner, the two control elements work together, complementing each other. You can allow the EOS Elan/100 to automatically control these variables. Or you can control one, or both, as explained in detail later.

Shutter Speed Effects

While the exposure changes are equivalent for either f/stops or shutter speeds, the resulting image will appear very different,

17

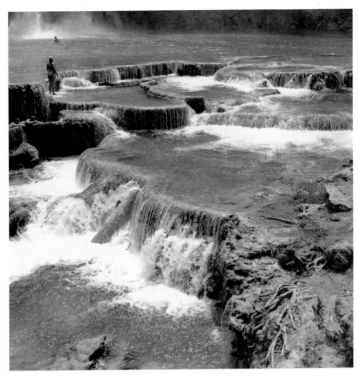

Running water is one of the best subjects for showing off the effect of shutter speed on subject motion. Photo: Paul Comon

depending on which exposure control has been adjusted. Shutter speed, in addition to controlling exposure, will significantly affect the way motion is portrayed in a photograph. Commonly, the shutter speed is used to "stop" a subject and ensure that it appears sharp in the photograph. The photographer or the camera evaluates how fast the subject is moving and chooses a shutter speed to freeze the action. If the subject is not in motion, a fast shutter speed is obviously not necessary. An exposure taken at 1/250 second is usually sufficient to render even an active subject, such as a child, sharp. At 1/1000 second or higher, a fast-moving subject will be stopped: a high jumper or water from a fountain will be "frozen" in mid-air, for instance.

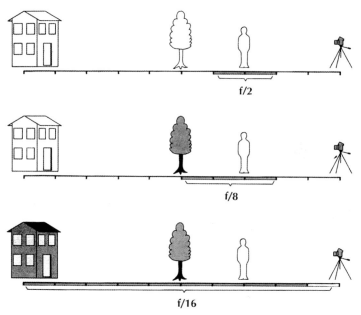

f/2

f/8

f/16

The smaller the aperture (opening), the greater the area which is reproduced in acceptably sharp focus - the so-called, depth of field.

Shutter speed can be used to catch motion that is usually missed because it occurs too fast or the moving subject can be allowed to blur by using a slow shutter speed, thus conveying the impression that the movement is happening too fast for the camera to record. In the latter case of blurred motion, the photographer has two additional choices. Either hold the camera still to record all non-moving objects sharply, allowing the moving subject to blur, or follow a moving subject using a panning motion and a slow shutter speed which will render the surroundings blurred, but the subject relatively sharp.

In addition to subject movement, you must also take into account the effect your own movement has on image sharpness. No one can hold a camera as still as a tripod. Camera movement can ruin a photograph, even at relatively high shutter speeds if the camera is not properly supported. Whenever possible, try to

stabilize yourself by leaning against a wall or rest your elbows on a stable surface like a table top. The reciprocal of the lens' focal length is a common determiner of the minimum shutter speed for hand holding the camera. In other words, for a 50mm lens use 1/60 second as a minimum; for a 100mm lens, 1/125 second; a 200mm lens 1/250 second and so on. Generally, it is not a good idea to use shutter speeds below 1/30 second when hand holding the camera.

A tripod is a more certain defense against camera movement. For greater mobility than a tripod will afford, a monopod may be a better choice. If neither a tripod nor a monopod are available, there is always the possibility that the camera can be supported on a table or other flat surface. No matter how steady the camera is held, if the shutter speed is slow and the subject is moving, motion blur may occur. Slow shutter speeds are recommended only if the subject is still or subject movement is desired.

Aperture Effects
In addition to controlling exposure, the aperture affects the depth of field in a photograph. Depth of field can be described as the zone of acceptable focus which extends beyond and in front of the point of focus. A larger aperture (lower number) provides very shallow depth of field and a smaller aperture (higher number) has a larger zone of sharp focus.

The focal length of a lens will also affect depth of field. A telephoto lens appears to provide less depth of field while a lens with a shorter focal length provides more. However, this generalization about focal length is only true if the lenses are used from the same position. Thus, if you are shooting with a 50mm lens and a person to your left has a telephoto lens, such as a 200mm, while another to your right has a 28mm wide-angle lens, then this statement would hold. However, if the person with the telephoto lens moved further away from the subject and the person with the wide-angle lens moved closer so that all three pictures produced the same size subject on film, the depth of field would be exactly the same.

One of the major benefits of depth of field is that it allows the photographer to control the visual relationship between the subject (main point of focus) and the rest of the scene. Using a large aperture and a long lens can render only the main subject in focus and blur a subject's surroundings. This is an excellent technique if

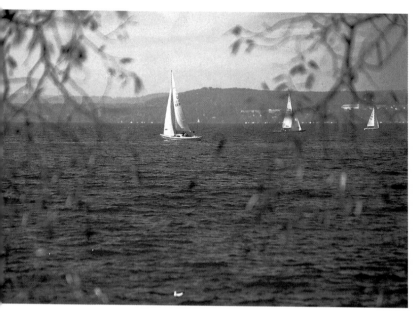

Selective depth of field made the leafy branches in the foreground appear as a soft blur framing the sailboat. Photo: Bob Shell

you want one object in the photograph to be the point of interest, for example in a portrait. In the opposite situation, using a small aperture and shorter lens, the background and foreground are all in focus and there is more of a sense of integration between all of the elements in the picture. In this case, there is usually some relationship between the subject and the surroundings, if you're photographing your family in front of the Grand Canyon, for instance.

The EOS Elan/100 is equipped with a Custom Function which provides depth of field preview. For more information, read the "Custom Functions" section in the chapter, *Special Functions*.

The Image Zone

The pictograms on the Command Dial of the Elan/100 symbolize the camera's operating modes. Canon divides these modes into three levels of sophistication—the Image Zone, the Creative Zone,

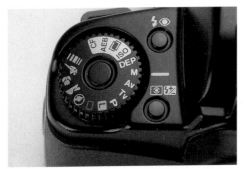

The Command Dial of the EOS Elan/100 is divided into three sections; the Creative Zone, the Image Zone (denoted by pictograms) and the Special Functions (isolated by the white box). The "L" setting shuts the camera off and locks the shutter release button.

and a set of Special Functions (or Useful Functions as Canon calls them.) The simplest operational level is the Image Zone, indicated by the six pictograms located counterclockwise from the Locked (L) position. These six comprise, in order: Full Auto (green rectangle); Portrait (face); Landscape (mountain); Close-Up (flower); Sports (runner); and Bar-Code Program (parallel lines).

Each mode sets the metering, exposure-control, focusing, and film-advance systems in ways that are appropriate for a particular type of subject. To understand what each mode entails, we first have to examine the range of settings the camera is capable of making.

Programmed Exposure
All of the Image Zone modes make use of Programmed Exposure, in which the camera sets both the shutter speed and the f/stop. Canon describes the system used on the Elan/100 as Intelligent Program AE (autoexposure), because it takes the focal-length and aperture range of the lens into account to choose appropriate exposure settings. For example, with a 500mm telephoto lens in place, the program will choose a shutter speed of at least 1/500 second whenever possible to facilitate hand-held shooting. If lighting conditions do not permit such a shutter speed, even with the lens wide open, the Camera Shake Indicator will blink in the viewfinder. If you use a zoom lens, the program "knows" what focal length is set and adjusts the program accordingly.

Some of the Image Zone modes are biased to favor particular exposure settings, whether high shutter speeds, wide apertures, or small apertures to produce a particular effect. In the more advanced Creative Zone, the Programmed Exposure mode can be

shifted by the user to favor a desired type of setting; this shift option is not available in the Image Zone. The Elan/100 also offers several non-program exposure modes, but these also are unavailable in the beginner-oriented Image Zone.

Full Auto

As the name implies, Full Auto is an all-purpose mode that lets the camera do the thinking. In fact, the designers of the Elan/100 have put quite a bit of thought into just how the camera should operate in this "PHD" (push here dummy) configuration. That makes Full Auto a fine way to start with the Elan/100 and the best choice when other people will be using the camera. Clever as it is, however, Full Auto only begins to hint at the Elan/100's capabilities.

So what happens when you set the Command Dial to the mysterious green box pictogram? The exposure system is set to the standard Programmed AE, controlling the f/stop and shutter speed as described above. The system makes every effort to maintain a hand-holdable shutter speed and warns you to use a tripod or the built-in flash when that is not possible. (Use of external flash units is not recommended in the Image Zone.) Meanwhile, the metering system uses the advanced Evaluative pattern and the film-winding mode is set to Single Exposure. All of these settings are indicated on the top-deck LCD panel. This combination of modes should produce the highest possible percentage of acceptable images without wasting film and without user input. And, not to belabor the point, no user input is possible in Full Auto.

Normally, the Single Exposure mode is coupled with One Shot AF. In the Full Auto mode, however, the autofocus system automatically switches between One Shot and AI Servo, depending on the subject. With a stationary subject, you get One Shot operation; if the camera senses subject motion, it switches to AI Servo, complete with Predictive Focus capability. The LCD panel shows the logos for both AF modes, with arrows between them to indicate that either one may be in use.

The only way the photographer can be sure which AF mode is operating is to press partway on the shutter release. If the focus locks, you've got One Shot; if not, AI Servo is working. This is more a matter of curiosity than necessity because the Elan/100 can be depended upon to choose the appropriate AF mode.

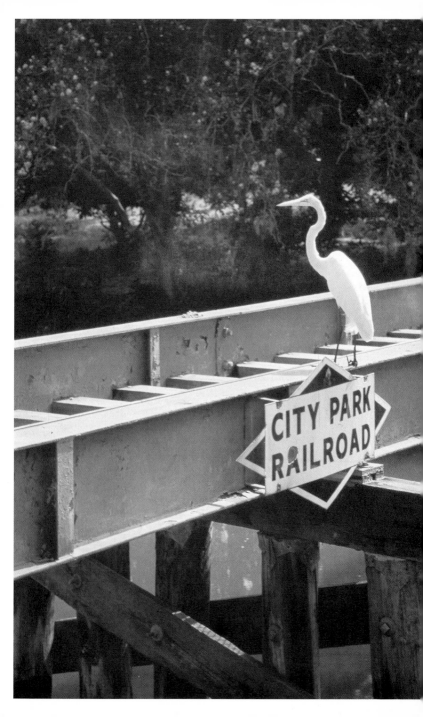

One small complaint: the automatic switching is so useful, I'm sorry it is only available in the Full Auto mode.

Portrait

When choosing a mode with a more defined identity, such as Portrait, you may wonder whether you are truly limited to that kind of subject. What if you quickly turn around and try to shoot a landscape or a close-up? Perhaps such a question only occurs to a writer of guidebooks, yet it does make a smidgen of sense.

What Portrait means, in this case, is the combination of operating modes that the Elan/100 designers think will work best for medium-close pictures of people. They assume you will be shooting with a longer-than-normal lens, at moderate distances (probably ten feet or closer), and that you want a sharp subject against a soft background. So when those parameters apply, whether the subject is a spouse or a skunk, Portrait is the mode to choose.

More specifically, the Portrait settings include One Shot AF, Continuous film advance, and Evaluative metering. The autoexposure program favors wide apertures to limit depth of field. As mentioned earlier, One Shot AF is more commonly paired with Single Exposure film advance. Yet, in this case, the One Shot/Continuous duo is appropriate.

When creating portraits, you are unlikely to accept any image that is unsharp. The best way to ensure sharpness is with One Shot AF, which only lets the shutter fire when the AF system has established positive focus. Every portrait photographer knows, however, that great facial expressions inevitably occur an instant after the picture is taken. By simply pressing the shutter release, you can create a series of portraits, similar in composition but (in all likelihood) with a range of expressions. You may even want to display them as a group.

There is an inevitable trade-off in this arrangement. If you keep your finger on the shutter release, only the first image in each series

When a perfect photo opportunity presents itself, don't miss the shot because you were fumbling with the camera controls, use the Full Auto mode. Afterwards, you can change the camera settings to take additional pictures, but at least you'll have one shot if your subject flies away. Photo: Bob Shell

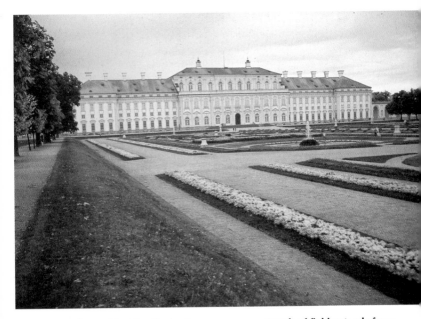

A perfect subject for the landscape program. Depth of field extends from the gardens in the foreground through to the mansion in the background. Photo: Bob Shell

is guaranteed to be sharp. The Elan/100 does not focus on the succeeding pictures, following the assumption that camera-to-subject distance will remain constant. With shallow depth of field and a vivacious subject, such an assumption may not be warranted. Of course, the camera will refocus if you take your finger off and then partially depress the shutter release button to reactivate the AF system. It would be nice to be able to change the AF mode to suit the portrait subject but that would entail more user involvement than is allowed in the Image Zone.

Landscape

As the mountain-and-cloud pictogram suggests, the Landscape mode is intended for horizontal images of distant subjects. Unlike the Portrait mode, Landscape enhances depth of field by setting a moderate aperture, even if that requires a slow shutter speed.

The EOS Elan/100's Landscape Program is perfect for subjects such as this. The preset combination of autofocus, a custom program that selects a small aperture for great depth of field, and single frame film transport is designed for optimal results in scenic photography. Photo: Bob Shell

In such cases, the Camera Shake indicator blinks to suggest that you use a tripod. If you choose to hand hold the Elan/100, be aware that the AE program will not adjust the shutter speed to ensure a steady image. And you can't use flash to throw some light on the scene. The Elan/100's built-in flash will not fire in Landscape mode. Despite the best efforts of tourists at the Empire State Building, flash just doesn't work for distant scenics.

If depth of field is the goal, why is the Landscape mode more likely to set f/5.6 than f/16? First of all, the program is intended for use with wide-angle lenses with great inherent depth of field. For a typical wide-angle lens, sharpness actually decreases at very small apertures due to the effects of diffraction (light bending) around the tiny opening. An aperture of f/5.6 or f/8 is likely to give much better results. And when you focus on a distant subject, a considerable zone of sharpness is created in front of and

27

(especially) behind the chosen distance. (If you still need more depth of field, perhaps for a near/far composition, there are several Creative Zone modes that will provide it.)

Because landscapes tend to be stationary (except sometimes in California), the Landscape mode uses One Shot AF and Single Exposure film advance. In this mode, Evaluative metering is particularly effective. It can easily recognize that the bright area at the top of the image is the sky and adjust the exposure to preserve detail in the foreground. Unfortunately, the novice photographer will not learn much from the camera's heroic efforts, which is the shortcoming of evaluative metering. If you prefer vertical landscapes, with the sky at the short end of the frame, it might be better to choose a Creative Zone mode that allows Partial metering.

Close-Up

It may seem odd, but the Close-Up mode tends to choose exposure settings very similar to those of the Landscape mode. Although the subjects are totally different, the f/stop requirements are virtually the same. To see why this is so, let's backtrack.

Close-Up is intended for large-scale images of small subjects such as flowers and insects. For best results, Canon recommends the use of a macro lens or a zoom lens with a macro setting. An ideal choice might be the EF 100mm f/2.8 Macro lens, although a Canon zoom lens with close-up capabilities will also give good results. Using the telephoto setting of a zoom lens is another option which produces satisfactory magnification provided the subject is not too small. Also, a moderately long focal length allows for a comfortable distance between the lens and the subject, creating a more pleasant visual perspective. By working at least three feet from the subject, you can make full use of the built-in flash without any chance of the lens blocking part of the illumination.

For the typical close-up, you want enough depth of field to render the entire subject sharply but still leave the background as a soft blur. The situation is visually similar to a portrait, except that

Flowers are probably the most popular subject for the Close-Up mode. Although the Close-Up mode favors an aperture of f/5.6 for maximum sharpness and depth of field, using the telephoto setting of a zoom lens made the background a blur. Photo: Bob Shell

you are much closer to the subject. Depth of field is shallower at close-up distances so an aperture of about f/5.6 will usually create the desired look. By coincidence, that is also what the Landscape mode favors for its vastly larger subjects.

Another similarity with Landscape is that the Close-Up mode sets the appropriate aperture and lets the shutter speed vary as necessary. The system will choose f/5.6, even in dim light, so heed the Camera Shake and Use Flash warnings. Using just a tripod is not necessarily the solution because it cannot stop subject movement, for instance flowers being stirred by a breeze. Flash often must be used as well because it produces a very short exposure time which stops motion.

Close-Up also uses the same focusing and film-winding modes as Landscape: One Shot AF and Single Exposure. Unlike Landscape or any other Image Zone mode, Close-Up forgoes Evaluative metering in favor of the Partial pattern. The theory is that your main subject is likely to be centered in the viewfinder, and may be radically different in brightness from the surrounding area. Think of a white flower surrounded by dark green leaves. In case you prefer an off-center composition, point the camera at the flower and hold the shutter release half-way in. This locks the exposure and the focusing distance. Then recompose the subject in the viewfinder, being careful not to change the camera-to-subject distance, and press the shutter button all the way to take the picture.

Sports

If your idea of action is a chess tournament, you probably won't have much use for the Sports mode. This is the movement-oriented program of the Image Zone, dedicated to using high shutter speeds to freeze fast action. If that means the lens will be shooting wide open (as it often does), so be it.

Canon recommends the use of a telephoto lens, such as the EF 70-210mm f/3.5-4.5 USM, to "bring your subject closer." That's good advice, although my choice would be an even faster fixed focal length optic, perhaps the EF 200mm f/2.8L USM, or for outdoor sports the 300mm or 400mm lenses of the same speed. The faster the lens, the higher the available shutter speed. And with the quick, accurate AF system of the Elan/100, you can be confident the subject will be nailed.

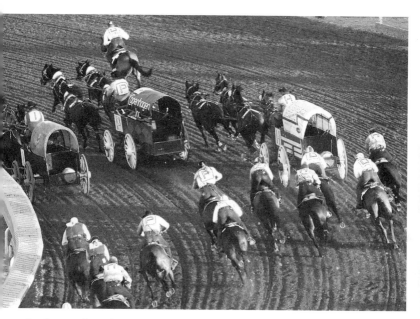

For fast moving subjects like these galloping horses, choose a fast shutter speed to stop the action and use a high-speed film. Photo: Peter K. Burian

The Sports mode automatically configures all camera systems for active subjects. Autofocus is achieved in the AI Servo fashion, complete with the much-appreciated Predictive Focus function. This is logically coupled with Continuous film advance so you can make a series of exposures at up to 2.5 frames per second.

The combination of AI Servo and Continuous allows the AF system to be constantly active, making required adjustments up to the instant each picture is taken. The Sports mode gets the image as sharp as possible, given the extreme time constraints, yet always allows the shutter to fire. Every frame may not be perfectly sharp, but the percentage of successful pictures will be higher than most. (Note that the maximum rate is 1/2 frame per second slower than with a One Shot/Continuous combination. That's because the AF system focuses each picture in the AI Servo mode, rather than just the first picture of each series.)

The heat of action does not lend itself to subtle fiddling with exposure settings, so Evaluative metering handles the chore. Exposures can be made with available light only, because the built-in flash does not operate in the Sports mode.

Sports photographers sometimes judge a camera by the speed of its motor drive. To them, a "professional" SLR should be capable of five frames per second, or even more. There is some logic to this, particularly if you make a living shooting for *Sports Illustrated* (basketball, not bathing suits). At that level of performance, every nuance of rapidity is important, and the Elan/100 just doesn't make the cut.

For the occasional sports photographer, however, the equation is a little different. At five frames per second, you can run through a 36-exposure roll in about seven seconds. Is that appropriate for a high-school football game? Also, successful sports photography depends on anticipation and quick reflexes (yours and the camera's), rather than pure shooting speed. A well-timed shot, or a short series, is the best answer, not a machine-gun burst of speed.

Bar-Code Program
The final Image Zone mode is the most unusual by far. It is symbolized on the Command Dial by a pictogram of a bar code, those ubiquitous parallel lines that tell a check-out scanner the price of a box of cornflakes. With the Elan/100, however, it is not price but subject information that is being conveyed.

To use the Bar-Code Program mode, you first have to find an optional Bar-Code Reader and its accompanying Bar-Code Book. That may not be easy, because Canon no longer supplies these items. A serious camera shop may still have some, or perhaps one could be borrowed from an Elan/100 owner fortunate to have previously purchased one.

The Bar-Code Book has sample photographs of various challenging shooting situations. Next to each illustration is a bar code containing the camera-operating parameters used to make the picture. If you are interested in photographing skiers, for example, you look through the book and find an appropriate picture. Scan the accompanying bar code with the Bar-Code Reader. Then press the end of the Reader against the Bar-Code Receptor on the side of the Elan/100. Finally, push the transmission button on the receptor to send the program code into the camera. At that point, a beep

sounds and the bar-code program number is displayed on the top-deck LCD panel. The AF, film-advance, and exposure systems of the Elan/100 are now set for fast-moving subjects against a bright background.

Normally, you do all this while the Command Dial is at the Bar-Code position. The new program can be used at any time simply by turning the dial to this setting. If you wish to input more than one Bar-Code Program, follow the same procedure but with the Command Dial set to another Image Zone position. Up to four additional Bar-Code programs can be input, replacing the Portrait, Landscape, Close-Up, and Sports modes. (The Full Auto program cannot be replaced.) Any or all of these Bar-Code programs can be changed or removed instantly using the Bar-Code Reader. By the way, if you do not input a program, the Bar-Code position on the Command Dial simply duplicates the Full Auto mode.

Metering Patterns

The Elan/100's TTL (through-the-lens) lightmeter can "read" an available-light scene in three distinctly different ways. By far the most sophisticated is Evaluative Metering, which uses the meter's six-zone SPC (silicon photo cell) to measure brightness and contrast throughout the image area. This information is evaluated by computer algorithms that compare the current situation with a database of lighting patterns in the camera's memory. For example, the Elan/100's evaluative meter may "recognize" a backlighted subject and adjust the exposure settings to prevent a silhouette. (If a silhouette is the desired effect, the photographer should not use an Image Zone exposure mode.)

As "smart" as it is, you should not expect evaluative metering to anticipate your personal desires; it is designed to create an exposure that the average photographer would consider acceptable in any given situation. This is a formidable task and the Elan/100 performs it well.

The most traditional of the three metering patterns is center-weighted averaging, a rather low-tech approach that simply measures the entire scene, with added emphasis on the central area indicated in the viewfinder. Advanced photographers sometimes prefer such a system because they can always be sure what it is

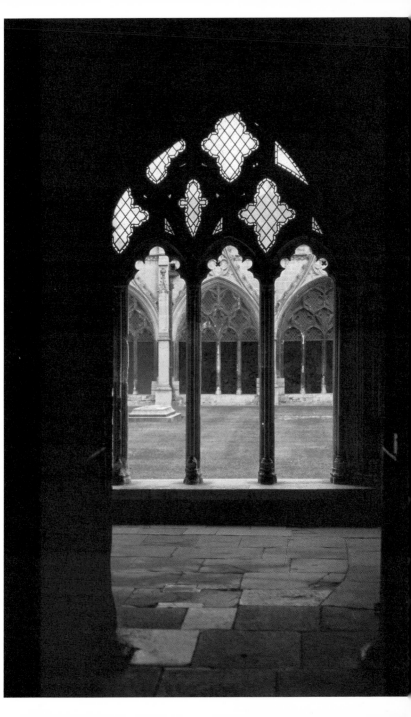

doing; unlike evaluative metering, a center-weighted averaging system will never try to out-think the photographer. However, this metering pattern is not very useful to the beginner, so it is not available in any of the Image Zone modes.

Finally, there is Partial Metering, which measures only the central 6.5% of the image area, shown by a circle on the focusing screen. While not quite a "spot" meter (except when used with long telephoto lenses), this mode allows the photographer to aim the meter at the most important area of the subject. The reading can be "locked in" by pressing gently on the shutter release button. Alternately, you can read several important areas of the image, noting the exposure recommendation for each. This will tell the experienced photographer whether all of these areas are within the exposure-latitude range of the film. Partial metering is easily misused by the novice, however, and only one of the Image Zone modes uses it.

Autofocus

The Elan/100 offers two types of autofocusing, One-Shot AF and AI Servo AF. Each type is best suited for a particular kind of subject. By choosing an Image Zone mode you are effectively telling the camera what kind of subject is being photographed.

In the One-Shot AF mode, a picture can only be taken if the AF system has successfully focused on a subject. This mode is best used with stationary subjects, when you have time to achieve perfect focusing with no risk of losing the shot. In fact, the Elan/100 focuses so quickly and positively that One-Shot AF will often work with slowly moving subjects as well. As mentioned earlier, the focus setting is held until you either take the picture or stop pressing the shutter button. In this mode, a separate AF measurement is made for each photograph.

◁ **Although Evaluative Metering produces excellent exposures in most situations, it would be the wrong choice for a photo like this one. To create a silhouette, use Partial Metering and set exposure for the view through the window. Photo: Bob Shell**

AI Servo AF is better suited to moving subjects. As long as you hold the shutter-release button partway in, the AF system focuses continuously. When you press the shutter release button all the way, the picture is taken whether or not the focus setting is exactly correct at that moment. The theory is that you're better off getting an almost-perfect shot at the chosen moment than a perfect shot that's a half-second too late.

Focusing accuracy with moving subjects is greatly enhanced by the Elan/100's Predictive Focus function, which is automatically engaged in the AI Servo AF mode. Based on the distance, speed, and direction of a moving subject, this system predicts the focusing distance at the moment of exposure. With subjects that are moving in a steady fashion, Predictive Focus effectively compensates for the inevitable lag between the time you push the shutter button and the instant the picture is actually taken. Erratically moving subjects may fool the system, but they fool experienced photographers as well. Because the AF system is continuously active in the AI Servo mode, the focus setting cannot be locked.

Manual focusing is always available, even in the Image Zone. Simply move the Focusing Mode switch on the lens to the "M" (manual) position and focus with the Focusing Ring of the lens until the viewfinder image looks sharp. If you press the shutter button partway in, the In-Focus Indicator in the viewfinder will illuminate when proper focus is achieved. Most photographers will only be focusing manually on those rare subjects that baffle the AF system; in such cases, the In-Focus Indicator will not operate either.

Film Advance

The film-winding system, like the AF system, offers two possible modes, each suited to a particular type of subject. Single Exposure mode, indicated by a single box on the top-deck LCD panel, advances the film one frame each time the shutter release button is pressed. As you might surmise, this approach is best suited for stationary subjects, and it is usually paired with One-Shot AF.

For fast-moving subjects, you're better off with Continuous Exposure, indicated by overlapping boxes on the LCD panel. Press the shutter release and pictures are taken continuously, at a rate of

up to three frames per second. The Elan/100 stops firing when you lift your finger or when you run out of film (which doesn't take long at that rate). At slow shutter speeds, the framing rate is lower. Because Continuous Exposure is meant for moving subjects, it pairs well with AI Servo AF.

In the Creative Zones, the photographer can use the Drive button on top of the camera body to choose either film-advance mode. In the Image Zone, each mode is linked with the film-advance style best suited to the subject and cannot be changed by the photographer.

Self-Timer

The Drive button also serves an additional purpose which is to select the Self-Timer/Remote-Control function. Push once and a clock/remote-control pictogram appears on the top-deck LCD panel. If you then press the shutter button, a beeper starts sounding. Eight seconds later, the Self-Timer Lamp blinks for two seconds, then the picture is taken. The timer can be cancelled at any time with another push on the Drive button.

It is possible that stray light may enter the viewfinder and adversely affect a self-timed exposure. To prevent this, remove the eyecup and cover the eyepiece with the blind built into the camera strap. The same caution applies to exposures made with the optional Remote Controller RC-1.

Using the Built-In Flash

When working in the Image Zone, you have two choices of illumination: existing light and/or the built-in flash unit. (External flash units should only be employed in the Creative Zone.) That is no great limitation, however, because the flip-up flash is surprisingly powerful and versatile. It is also the one feature that varies significantly between the EOS Elan and the EOS 100.

For esoteric patent-related reasons, the two models offer differing degrees of flash automation in the Image Zone. With the EOS 100, the flash pops up automatically in low-light or backlighted situations. This occurs only in the Full Auto, Portrait, Close-Up,

and certain Bar-Code Program modes; the flash will not lift or fire in the Landscape or Sports modes. Once the flash is raised, it fires only when needed. Unlike older units, the flash is ready almost instantly, thanks to the lithium battery.

The EOS Elan, operates a little differently. If the metering system detects a low-light or backlighted subject, it causes a lightning bolt symbol to blink in the viewfinder. This alerts you to push the Flash Button near the Command Dial. The flash pops up and in that position it will always fire. The same mode limitations apply: if you push the Flash button in the Landscape or Sports modes, the flash will not pop up. Even if the flash unit has already been raised in another mode, it won't fire in Landscape or Sports.

The Elan/100's pop-up flash is quite powerful for its size.

In all other aspects of flash operation, the Elan and the 100 are identical. When the built-in flash is active, the shutter speed is automatically set to 1/60 or 1/125 second, depending on the ambient light level. If the center of the image area is appreciably darker than the edges (presumably a backlighted situation), the flash only emits enough light to make up the difference. When this area has been properly illuminated, as measured by the TTL (through-the-lens) flash-metering system, flash output is automatically quenched. Therefore, the aperture setting chosen for the bright surroundings will also be appropriate for the central area lighted with fill flash.

In low light, the flash is the main illumination for the entire scene. The shutter speed is set to 1/60 second, and the aperture to a moderate value, such as f/4. As the flash fires, TTL metering

The maximum shooting distance of the built-in flash unit is approximately ten feet with an 80mm lens at f/5.6. This may seem limiting, but it can prevent distracting objects in the background from being illuminated. Photo by Scott Augustine/Leichtner Studios

measures the overall exposure. When it is correct, the flash immediately shuts off. To the user, there is no operational difference between fill flash and low-light flash.

Of course, the camera's little flash can't light up Yankee Stadium. It has a guide number of 40 (in feet) or 12 (in meters) at ISO 100 with a 28mm lens; corresponding numbers are 60 or 17 with an 80mm lens. Divide the guide number by the maximum aperture of the lens in use and you have, approximately, the maximum flash distance in feet or in meters.

With the ED 28-80mm f/3.5-5.6 USM zoom, the longest flash distance is 3.4 meters (about 11 feet) at 28mm, and three meters (about 10 feet) at the 80mm setting. (If the lens had a constant maximum aperture, the range would be longer at the telephoto setting.) By switching to ISO 400 film, you double the maximum shooting distance, while hardly changing the minimum distance of about three feet. Faster lenses offer greater flash range as well.

The reason the guide number varies with focal length is very simple: the motorized reflector in the flash unit automatically adjusts to the focal length of the lens in use. It throws a wide pattern of light with a 28mm or 35mm lens and a much tighter beam at 50mm to 80mm (or more). The light output is used most efficiently this way with no wide-angle vignetting and no wasted spill light at longer focal lengths. As you turn the lens' zoom ring, you can hear the flash reflector move.

The same button that pops up the flash also controls the red-eye reduction system. Once the flash is up, a second press of this button activates the red-eye system, indicated on the top-deck and viewfinder LCD panels with a stylized eye pictogram. When you press the shutter release all the way in and hold it there, the Red-Eye Reduction Light shines brightly for about 1-1/2 seconds, causing the subject's pupils to contract. This time period is indicated on both LCDs by a set of parallel lines that gradually disappear. When they're gone, the Reduction Light turns off, the shutter opens, and the flash fires.

If you wish, you can activate the Red-Eye system in two steps. First press lightly on the Shutter Release Button, then push all the way in when the parallel lines have disappeared. This way, you can decide whether you still want to take the picture that looked so promising 1-1/2 seconds earlier. Particularly when dealing with squirmy subjects such as children, the choice is a valuable one. As

The EOS Elan/100's red-eye reduction mode helps to eliminate red-eye for perfect results with flash. The TTL automatic flash compensated for the wide exposure latitude, retaining detail in both the black tuxedo and the ivory wedding gown. Photo by Scott Augustine/Leichtner Studios

with any red-eye reduction system, best results are obtained if the subject looks at the reduction light while it is on, then looks slightly away from the flash when it fires. The Red-Eye Reduction System can be cancelled at any time with a push of the Flash Button.

Be careful when using the built-in flash at focusing distances closer than about three feet. As mentioned in the Close-Up section, the lens itself can block some of the light from reaching the subject. Certain other lenses cause similar problems, even at greater distances: large-aperture lenses such as the EF 20-35mm f/2.8L; long zooms such as the 70-200mm f/2.8L USM; and powerful telephotos such as the EF 300mm f/2.8L USM. Even with a smaller lens, be sure to remove the lens hood before using the built-in flash.

External flash units cannot be used in conjunction with the built-in flash. And, as mentioned earlier, such units will not operate in the Image Zone. The remarkable capabilities of Canon dedicated flash units and some surprising aspects of the built-in flash are discussed in later chapters.

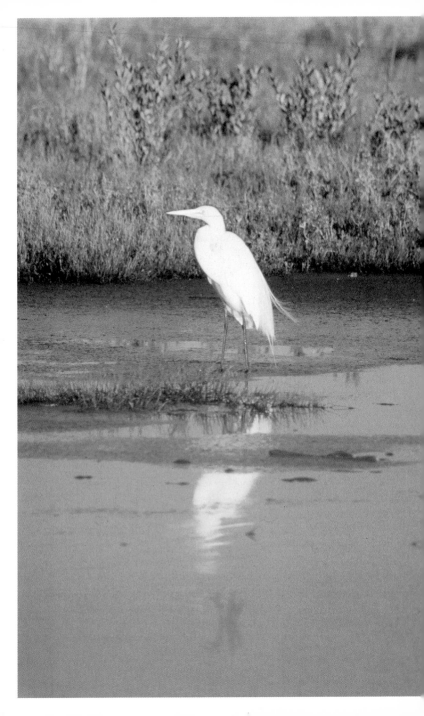

Advanced Operation

A most welcome aspect of the Elan/100 is that the camera can grow with the photographer. You may have noticed that all of the functions in the Image Zone, covered in the previous chapter, were set by turning just one control, the Command Dial. Yes, you needed to push the Flash button (at least with the Elan version), and of course the Shutter Release Button comes in handy. But the operation of the Image Zone is so simple that virtually any user of a point-and-shoot camera can master it in almost no time. There is really only one choice in the Image Zone: to leave the Elan/100 on Full Auto, or switch to a mode that corresponds to the subject being photographed.

The function of the Creative Zone is to offer more flexible choices for the more advanced photographer. Your knowledge of f/stops, shutter speeds, metering, depth of field, etc. lets you guide the Elan/100 in ways that suit your shooting style. Full, "intelligent" automation is still possible, as well as partial automation or complete manual control, as you wish. None of the alternatives are conceptually difficult, and all are simple to execute using a few well-designed controls.

Like the Image Zone modes, those of the Creative Zone are chosen with the Command Dial. Working counterclockwise from the Locked (L) position, these five modes are: Program (P); Shutter-Priority Autoexposure (Tv); Aperture-Priority AE (Av); Manual (M); and Depth-Of-Field AE (DEP). Before exploring how these modes work, let's examine a few additional controls and camera functions.

The Elan's sophisticated evaluative metering system maintains proper exposure, even in difficult lighting situations. Despite reflections from the water, the Snowy White Egret retains detail in the highlights, while the background is correctly exposed. Photo: Bob Shell

Autofocus, Film Advance, and Metering Modes

You may recall that in the Image Zone, the autofocus and film advance modes, and the meter pattern are all automatically selected when you choose an operating mode. For example, the Close-Up mode uses One Shot AF, Single Exposure advance, and Partial metering, while the Sports mode sets AI Servo AF, Continuous advance, and Evaluative metering. In the Creative Zone, however, the photographer chooses the focus, film advance, and metering modes manually in any combination. For your convenience, all Creative Zone modes offer standby settings: One Shot AF, Single Exposure advance, and Evaluative metering; any of which can be changed at any time.

Two of the selections are made with a pair of oval-shaped buttons located near the top-deck LCD panel. The red AF Mode button is used to choose the focusing mode, either One Shot or AI Servo. As noted earlier, AI Servo incorporates the Predictive Focus function as well. The LCD panel indicates either One Shot or AI Servo in a small red rectangle, but never both at once. (Only the Full Auto mode in the Image Zone automatically switches between the two AF modes.) If you prefer manual focusing, set the Focus Mode switch on the lens to M. This overrides the AF Mode button, and extinguishes the ONE Shot or AI Servo legends on the LCD.

The adjacent blue button has the more complex title of Film Winding Mode/Self-Timer/Remote Control button. Its status is indicated within a blue rectangle on the LCD. A single box means Single Exposure advance, a series of boxes signifies Continuous advance, and a combined clock/remote symbol indicates the combined Self-Timer/Remote Control mode. The latter mode is available in the Image Zone as well, but the two film-advance modes are only user-accessible in the Creative Zone.

To select the measurement pattern of the Elan/100's TTL metering system, push the small, black Metering Mode button located near the Command Dial. (This button also has the completely separate function of adjusting Flash Exposure Compensation, which will be discussed in the following chapter.) These patterns, as indicated within a set of brackets on the LCD panel, are: Evaluative (two semicircles with a dot between them), Partial (two semicircles), and Center-Weighted Average (a blank area within the brack-

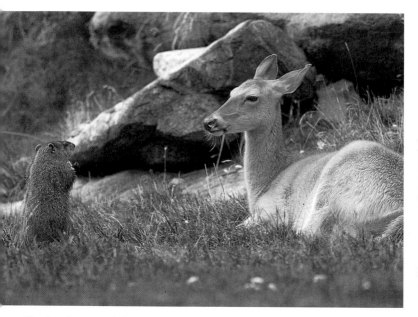

The Autofocus Lock feature offered in One Shot AF mode allowed the photographer to focus on the deer's face and then recompose the photograph to include the groundhog. Photo: Bob Shell

ets). To change the pattern setting, push the Metering Mode button, and simultaneously turn the knurled Main Dial in either direction. As we shall see, the Main Dial, located near the Shutter Button, is also used to set several other operating functions.

The Creative Zone

Program Autoexposure (P)

At first glance Program Autoexposure, or Program AE, appears similar to the Full Auto mode of the Image Zone. Both set the f/stop and the shutter speed according to the ambient light level and the ISO of the film being used. Each one attempts to keep the shutter speed high enough for hand held shooting with the focal length of

the lens in use. The two modes are even located on either side of the Lock position of the Command Dial, as if to suggest that these are the first choices in their respective zones.

As usual, reality is a little more complex than appearance. The Program mode allows far more flexibility than Full Auto, in the operation of the mode itself, and in other control settings. Essentially, Full Auto limits you to the aperture and shutter settings that the Elan/100 selects, with no user input. That's fine for a beginner, but a more experienced photographer may want to modify the AE program to suit his or her preferences. For example, you can select high shutter speeds for active subjects or small apertures for landscape shooting changing the exposure mode.

This is accomplished with the Program Shift function, which is always available in the Program AE mode. To use it, first tap the Shutter Release button to display the chosen f/stop and shutter speed on the LCD panel and in the viewfinder. If these settings are appropriate, just press the Shutter Release button and take the picture. To change them, rotate the Main Dial in either direction. From the photographer's point of view, turning the dial clockwise shifts the program to higher shutter speeds and correspondingly wider f/stops; moving it counterclockwise has the opposite effect.

Any amount of shift is possible within the lens' aperture range and the camera's shutter-speed capabilities (1/4000 second to 30 seconds.) The displayed exposure settings are your only indication of how much the Program has been shifted from its normal settings, or that it has been shifted at all. It would be nice to have a "shift" logo on the LCD, but there just isn't room. Program Shift automatically cancels after one exposure or if you move the Command Dial to another mode.

You may remember that in the Full Auto mode, advanced camera functions are preset and cannot be changed. By contrast, the Program AE mode lets you choose the Film Advance mode, Meter pattern and Autofocus mode. Although the standby settings of One Shot AF, Evaluative metering, and Single Exposure film advance are usually appropriate for this general-purpose mode, I wish the auto-switching AF was available in Program as well.

If you make changes in the focus, advance, and/or metering modes, they remain for as long as the camera is in any Creative Zone mode. Even if you turn the Command Dial to Lock, the quiescent camera will remember your preferences. If you move the dial

For the more experienced photographer, Program AE mode allows greater control over exposure settings. The Program Shift function was used to select a small aperture and the camera automatically sets a corresponding shutter speed. Photo: Bob Shell

to the Image Zone, however, these settings are lost. In that case, the Program reverts to its standby values.

When the ambient light is insufficient for hand-held exposure, the low-light warning blinks in the viewfinder. (For some reason, the Use Flash warning light does not operate in the Program AE mode.) You can put the Elan/100 on a tripod, pop up the built-in flash, or (unlike Full Auto) use a Canon external flash unit. With the built-in flash, the shutter speed is set to either 1/60 or 1/125 second, depending on the ambient light level. The aperture is automatically placed at a moderate value, generally f/2.8 with low-speed film, and f/4 for films of ISO 100 or higher.

As explained in the previous chapter, the TTL flash system controls the output of the built-in flash, whether for fill flash of back-

lighted scenes, or as the main illumination for low-light situations. (To fine tune the flash, use Flash Exposure Compensation, as described in the following chapter.) The Program Shift function, however, has no effect when the built-in flash is operating.

The Program mode occasionally blinks a warning signal to alert the photographer of possible flash exposure problems. When using the flash for daylight fill-in, the maximum flash sync speed of 1/125 and the minimum aperture of the lens (i.e. f/22) may appear and blink on the LCD panel and in the viewfinder to indicate overexposure. The simplest remedy is to turn off the flash, but using a slower film is another possible solution.

I should mention that these exposure warnings apply to ambient light exposure as well. If you happen to be photographing a sun-drenched desert with high-speed film, you may notice the maximum shutter speed and highest f/number will flash on the camera's displays. This means, of course, that the image will be overexposed, even at the extreme settings of 1/4000 and f/22 (or f/16, or f/32, as appropriate). When faced with this stunning surprise, add a neutral-density filter, or switch to slower film speed.

Likewise, in extremely low light, the longest exposure time (30") and the maximum aperture of the lens will flash to indicate underexposure. A faster lens and/or faster film are possible solutions which would allow the exposure to be made. Flash could also be used although it would change the character of the image. Longer manually-timed exposures are possible using the Bulb setting as discussed in the "Manual Exposure" section.

The Elan/100 can take exposure measurements at light levels from EV -1 to 20, which should suit virtually any scene. The AF system has an operating range that is almost as wide, from EV 0 to 18. In low-light and/or low-contrast situations, a barely visible AF Auxiliary Light automatically projects a pattern onto the subject to improve focusing accuracy.

Shutter-Priority Autoexposure (Tv)

For absolute control of subject motion, there is no substitute for Shutter-Priority AE. This mode is indicated on the Command Dial by the symbol Tv, for "time value." And time is just what you're slicing when you turn the Main Dial; clockwise sets higher speeds (up to 1/4000 second) and counterclockwise sets slower ones (to 30 seconds). However, remember if you choose a long shutter

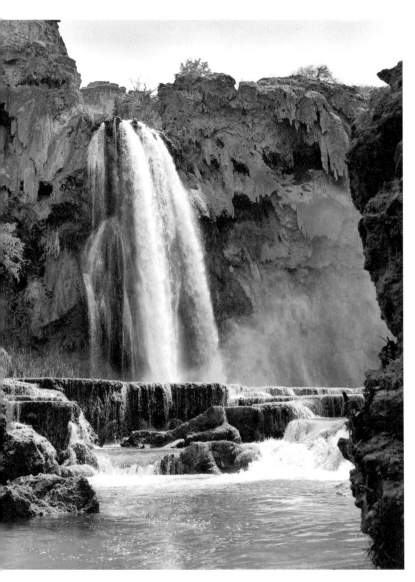

Although the shutter speed was fast enough to hand hold the camera, it wasn't fast enough to "freeze" the cascading water at Havasupai Falls.
Photo: Paul Comon

speed, the Camera Shake warning light will not appear. The reasonable assumption is that since you chose the shutter speed, you should be aware of its consequences.

In this mode, the chosen shutter speed is always visible on the LCD panel and in the viewfinder. A light touch of the Shutter Release button causes the f/stop chosen by the camera to appear as well. If the maximum aperture value blinks on the displays, it means the subject will be underexposed. A blinking minimum aperture value indicates the image will be overexposed at the chosen exposure settings. You can either change the shutter speed or accept a less-than-ideal exposure. With fast-moving subjects, this decision may not be as easy as it seems. By keeping the shutter speed too low, you may create what is often called a "well-exposed blur." Is that preferable to a dark, but sharp, image? It's your call, although the best approach is to avoid the dilemma by anticipating what you'll need to photograph a specific subject and planning accordingly. If you're photographing a horse race and want sharp, stop-action shots, choose a high-speed film and a fast lens. These will allow you to use fast shutter speeds with less chance of getting the underexposure warning. Overexposure is less likely to be a problem with fast shutter speeds. There are just not many situations that are too bright for 1/4000 second at f/22. However, if you intend to shoot at slow shutter speeds to emphasize subject motion, use a low-speed film and bring a neutral-density filter to avoid overexposure.

Shutter-Priority AE also operates with the built-in flash (or with Canon external flash units, as discussed in the flash chapter). Any shutter speed from 30 seconds to 1/125 second remains as you set it; higher speeds are automatically lowered to 1/125 second to ensure proper flash synchronization. Surprisingly, the f/stop setting chosen by the camera also remains the same as it would have been if the flash were not in use. For example, the ambient light exposure with ISO 400 film in a living room might be 1/30 second at f/2.8. In the Shutter-Priority mode, when you pop up the flash, those settings remain the same. Therefore, the flash is serving only to fill-in the shadows, and to lessen overall contrast. It is not intended to be the main light in the scene.

Two flash exposure warnings are possible in the Shutter-Priority mode. A blinking minimum aperture value (i.e. 22) on the camera's displays signal overexposure. If this appears, switch off the flash

unit, or set a higher shutter speed, up to the 1/125 second flash-sync limit. A blinking maximum aperture warns that the background will be underexposed, although the in-focus main subject will be exposed normally. Unless a dark background is desirable to accentuate the subject, lower the shutter speed until the aperture number stops blinking. This will not significantly affect the flash-illuminated foreground (unless the shutter speed is very slow), but it will brighten the background with additional ambient light exposure. Use a tripod if the shutter speed is too slow to hold the camera, or the background will be a well-exposed blur. Remember you must make this determination, the camera will not provide a warning.

For readers who skipped the previous section: Flash Exposure Compensation and ambient light Exposure Compensation are both available either separately or together in all Creative Zone modes, including Shutter-Priority. The standby operating modes are Single Exposure film advance, One Shot AF, and Evaluative metering; you can adjust any or all of them as you wish. The operating settings you choose in any Creative Zone mode carry over to any other, and are only cancelled when you shift the Command Dial into the Image Zone. Since most photographers use Shutter Priority for fast-action subjects, Continuous advance and AI Servo AF may be better choices.

Aperture-Priority Autoexposure (Av)
When depth of field is of paramount importance, Aperture-Priority AE is the mode of choice. Its designation on the Command Dial is Av, for aperture value. In this mode, you set the f/stop, and the Elan/100 automatically chooses the shutter speed.

Operation is basically similar to that of the Shutter-Priority mode. In Aperture Priority, however, the f/stop is altered when you turn the Main Dial, clockwise sets smaller apertures (larger numbers), counterclockwise sets larger apertures (smaller numbers). The chosen aperture value is always visible on the LCD panel and in the viewfinder; the shutter speed appears when you lightly push the Shutter Release button. If the speed is too low for safe hand-held shooting, the Camera Shake warning blinks in the viewfinder.

Two other warning signals occasionally appear in the Aperture-Priority mode. If the 30 second shutter speed (30″) blinks in the

This picture was shot in Aperture-Priority (Av) mode. By selecting a small aperture opening using the Command Dial, great depth of field was achieved. The camera automatically adjusted the shutter speed for correct exposure. Photo: Bob Shell

viewfinder, it means the image will be underexposed. Conversely, a blinking 4000 warns of overexposure, even at the top speed of 1/4000 second. In either case, use the Main Dial to shift the aperture value to a more suitable setting.

Aperture-Priority AE is commonly used for portraits and landscapes, two very different genres. What they have in common is the need to control background sharpness. When shooting portraits, you generally want just enough depth of field to encompass the main subject. Depending on the situation, the background may be out-of-focus yet still recognizable, or it may be rendered as an abstract, soft blur. In general, depth of field decreases as the lens focal length gets longer, the aperture gets wider, and/or the focusing distance gets shorter.

To create a classic landscape, on the other hand, you need plenty of depth of field. In a natural setting, you might have grass and trees in the foreground, a river running through the middle range, and mountains in the background. All of them need to be shown clearly, unless you have made a conscious decision to contrast sharp and soft areas. Fortunately, landscapes are

generally made at much greater focusing distances than portraits, increasing the inherent depth of field. Wider lenses and smaller apertures are common, further enhancing the effect.

Although the Aperture-Priority mode allows absolute control of these parameters, it does not provide a foolproof way of evaluating their effects. The Elan/100 has no depth of field preview control, which would let you manually stop down the lens to observe image sharpness. So you have to depend on depth of field scales, provided on EF fixed focal length lenses, but not on zoom lenses. The scales display the zone of relative sharpness in front of and behind the main subject, at various f/stop settings. Naturally, subjects nearer the center of this zone are clearer than those at the edges. Striking visual effects are created by the progression from sharpness to softness, as photographers learn from experience. (A fascinating alternative for controlling image sharpness is afforded by the Depth-Of-Field AE mode, discussed below.)

Flash operation in the Aperture-Priority mode is rather similar to that of Shutter-Priority. When you pop up the built-in flash, or attach an external flash unit, the exposure settings on the LCDs remain remarkably unchanged. An extreme example: Your camera is on a tripod in a very dimly lighted room. With only ambient light, exposure settings are f/2.8 and 1/2 second. You turn on the flash, and the shutter speed doesn't change. (Of course the aperture won't change either, because this is the Aperture-Priority mode.) As in Shutter-Priority, the flash is only serving to fill in the shadows, not as the main source of illumination. This effect preserves the "character" of the scene better than the typical overwhelming burst of flash light and can produce a more pleasing photo.

There are also two flash exposure warning signals in the Aperture-Priority mode. A blinking shutter speed value of125 on the LCDs indicates possible overexposure. As you know, the Elan/100 cannot (and will not) set a shutter speed higher than 1/125 with flash. So either turn off the flash, or set a smaller aperture to make the blinking stop. When the slowest shutter speed setting (30") blinks, the background will be underexposed, even though the main subject will be rendered normally. Again, you probably anticipate the solution, set a wider aperture to stop the blinking. Keep in mind that that 30" indicates a half-minute exposure, so definitely mount the Elan/100 on a tripod. If the background will

still be underexposed, even at the maximum aperture, you might want to reconsider your choice of locale.

Manual Exposure (M)
In the Manual mode, the photographer gets to turn off the Elan/100's exposure automation and make all the decisions. Before discussing why you might want to do so, let's examine how it's done.

When you turn the Command Dial to Manual Exposure, the shutter speed and f/stop are continuously displayed on the LCD panel. With a touch of the Shutter Button, these values become visible in the viewfinder as well. To change the shutter speed, you rotate the Main Dial, clockwise for higher speeds, counterclockwise for lower ones. The dial is not continuously variable, so you cannot keep turning clockwise from 1/4000 second to "bulb" (time exposure). This is a significant safety feature which prevents the inattentive photographer from totally sabotaging his exposures.

Each click of the dial changes the shutter speed by 1/2 stop, so the counterclockwise series reads out as 4000, 3000, 2000, 1500, etc. Such fine gradations are the product of an electronically-controlled shutter; mechanically-timed shutters generally move in full-step increments only. The full range of speeds is available, from 1/4000 second to 30 seconds, plus "bulb." Note that there is no Camera Shake Warning in the viewfinder, regardless of what shutter speed you set. Again, the assumption is that since you are avoiding the camera's automation, you must know what you're doing.

Lens apertures are set with the Quick Control Dial. To use it, you first have to turn the Quick Control Dial Switch to "I" (on). Then rotate the dial with your thumb, clockwise for smaller apertures (larger numbers), and counterclockwise for larger apertures (smaller numbers). Like the shutter speeds, the f/stops vary in 1/2-EV steps: f/2.8, f/3.5, f/4, f/4.5, etc. In other Creative Zone modes, the Quick Control Dial is used for Exposure Compensation. In the Manual mode, the compensation dial is not visible, because this feature is unavailable and unnecessary. After all, if you dial in your own settings, what is there to compensate?

The Elan/100 never leaves you without guidance, even in the Manual mode. When you touch the Shutter Button, an Exposure Confirmation display appears on the top-deck LCD, and in the viewfinder, along with the shutter speed and f/stop. The display

consists of a pair of arrowheads; one points to the right and contains a plus sign, the other points left and encloses a minus sign. You've probably figured out that the plus means overexposure, the minus signifies underexposure, and the two symbols together denote proper exposure.

With the camera in your hands, the relation between the Main Dial and the Quick Control Dial becomes obvious. Turn either dial clockwise, and you are choosing progressively less exposure, either with higher shutter speeds (on the Main Dial) or smaller apertures (on the Quick Control Dial). This realization simplifies manual exposure setting. If the overexposure arrow is glowing, turn either or both wheels clockwise (to the photographer's right, as indicated by the direction of the overexposure arrowhead). When underexposure is indicated, turn the other way (as shown by the underexposure arrowhead).

I must admit that the first time I tried the Manual Exposure mode, I thought the arrowheads were each backward. I intuitively wanted to turn the dials in the opposite direction, toward the arrowhead that was not yet lighted. That just proves that guidebook writers should read the instruction manual too.

Like all Creative Zone modes, Manual offers a full range of film-advance, meter-pattern, and focusing modes. Even if you're manually setting the exposure, there's no reason to forgo autofocus! The standby settings, once again, are Single Exposure advance, One Shot AF, and Evaluative metering. No argument with the first two, but Evaluative metering just doesn't meld with manual exposure settings. As mentioned earlier, the weakness of such "smart" metering is that the photographer really doesn't know how it arrives at its exposure recommendations. The electronic brain is mulling over an algorithm that reminds it of some prototypical scene, but there's no way for you to follow the camera's "train of thought." You may want to heed the wise counsel of the Evaluative mind, but there is no advantage in doing so manually.

As the instruction manual recommends, Partial metering is a much better choice in the Manual mode. That way, you can see what the meter is reading, or (better yet) choose the area or areas of greatest importance. If the main subject is very light, you might want to give *more* exposure than the meter suggests, to preserve the delicate tones. With dark subjects, you do the opposite. This may seem counterintuitive, but it is simply what view camera

Don't leave your camera at home when you go out in the evening. This photo required an exposure time of several seconds. The photographer was able to pull it off by supporting the camera on a railing while the shutter was open. Photo: Bob Shell

photographers call "placing" the exposure. Light meters are designed to render subjects as medium gray, and that may not be what you want at all.

In a roundabout way, I have just given the rationale for the Manual mode. There are times when you know exactly what you want, yet are not totally confident that autoexposure will produce the desired effect. A good example is an extremely contrasty night scene, such as a full moon over a meadow. An average reading might expose for the grass, making the scene look like daytime, and the moon appear like a white-hot sun. Evaluative metering might recognize the scene, and make a reasonable compromise between the moon and the foreground. Even if it does, remember that you know something the camera doesn't—what kind of film is being used. With color slide film, the best approach to our lunar scene might be to make a Partial reading of the moon, and choose exposure settings so the lunar surface just holds highlight detail. Color negative film may call for more attention to the dark foreground, choosing exposure settings to preserve shadow detail.

Maybe you would handle this scene differently, but that just emphasizes the value of Manual metering.

Flash operation in the Manual mode is still somewhat automated. The TTL metering system controls the output of the flash (whether built-in or external) to provide proper exposure of the in-focus subject at the set f/stop. What effect this will have on the background, you have to figure out for yourself—there are no warning signals. Fortunately, the Exposure Confirmation system continues to operate, although it virtually ignores the fact that flash is being used. So if you set an exposure that causes both arrow-heads to light, the background should be properly exposed. The Elan/100 will save you from disaster, however, by overriding any shutter speed setting higher than the 1/125 second sync speed.

Finally, Manual is the only mode that allows shutter speeds longer than 30 seconds. As you turn the Main Dial counterclockwise, the setting after 30" is bulb, a venerable term for manually-timed long exposures. You will notice that with the shutter speed set to "bulb," the Exposure Confirmation arrowheads disappear. This is because the Elan/100's meter can't provide guidance for an unknown shutter speed.

If you are shooting in extremely low light, the meter may be of no help at all. Then you simply have to estimate the exposure time, and hope for the best. There are situations, however, where there is just enough light for the meter to read. Let's say the indicated exposure is 30 seconds at f/1.4, as metered through a fast 50mm lens. You decide instead to use an 80mm lens, but the maximum aperture is f/2.8. You can translate the exposure (30 seconds at f/1.4 equals 120 seconds at f/2.8) to get a reasonable starting point. Keep in mind, however, that films tend to lose effective speed during very long exposures, a phenomenon known as reciprocity failure.

I have found some films that start slowing down with exposure times as short as a few seconds, while others are far more tolerant. Also, color films often shift in color rendition during multi-second exposures. This topic is worth an entire book, but the only brief advice I can give is: bracket exposures; experiment with color filtration; and keep careful notes.

Depth-of-Field Autoexposure (DEP)
As I mentioned earlier, the Elan/100 does not have a depth of field preview lever, and many Canon EF lenses lack d-o-f scales. As

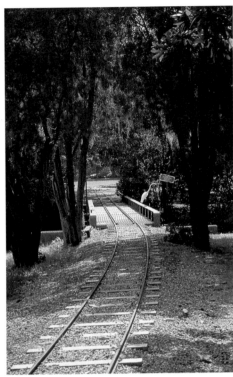

The railroad tracks are a "leading line" serving to draw the viewer's eye into the scene. The success of this compositional "trick" was dependent on the entire length of the line being in sharp focus so the viewer would follow it. DEP mode was used to select an aperture that would ensure this.
Photo: Bob Shell

useful as these absent features are, they do have some shortcomings. When you press a d-o-f control and physically stop down the lens, the viewfinder image tends to get mighty dark. You can squint through it and pretty much tell what's sharp, but it is not easy. Lens d-o-f scales can also be a challenge to the eyes, with a pair of tiny indicators for every available f/stop. And it's even worse trying to use them with zoom lenses, whose d-o-f varies with the focal length. In effect, Depth-of-Field AE is an electronic version of the d-o-f scale, which figures out what aperture you need and automatically sets it.

To use it, you turn the Command Dial to the DEP position. This sets the Elan/100 for a different sort of AE program. The aperture and shutter speed are not set immediately. You must first decide what is the nearest subject you want to have rendered sharply. Point the camera at that subject, so it is centered in the viewfinder's

autofocus brackets. Then press the Shutter Release button lightly. The lens focuses to that distance, and dEP 1 appears in the viewfinder and on the LCD panel. Now point the AF brackets at the most distant subject that needs to be sharp. Lightly press the Shutter Button again. Once more, the lens focuses on the chosen distance, and dEP 2 is displayed. The focusing and exposure systems now "know" what zone of sharpness is required. Now recompose the scene as you want it, and lightly press the Shutter Button for a third time. The lens automatically focuses on a point between dEP 1 and dEP 2 and the displays show the selected f/stop with enough depth of field to keep the nearest and farthest points in proper focus. An appropriate shutter speed is also displayed, to create the correct exposure at this aperture. Push the Shutter Button the rest of the way in, and the picture is taken at these settings.

If the required shutter speed is too slow for hand-held shooting, the Camera Shake warning blinks in the viewfinder. The only remedy is to use a tripod, because Depth-of-Field AE will not work with flash. If you try using the built-in flash (or an external unit) in this mode, all you get is Program AE, minus the d-o-f function.

To quote Mr. Scott of *Star Trek*, Depth-of-Field AE "canna change the laws of physics." The two points you choose have to be within the lens's potential depth of field range, at least at the minimum aperture. If you have a foreground subject at two feet, and a mountain in the background, it's going to require a *very* wide-angle lens and a very small aperture to bring them into focus simultaneously. If it can't be done, the minimum aperture value blinks in the viewfinder.

Wide-angle lenses are generally the best choice for this mode, although there is nothing to prevent a normal or telephoto lens from being pressed into service. If you use a zoom, however, be sure not to change the focal length setting after focusing on dEP 1. Depth-of-Field AE will still operate, but the results are not reliable.

The aperture chosen in this mode is the largest one that will provide sufficient depth of field. You are free to use the Program Shift to change the f/stop (and the accompanying shutter speed), without varying the amount of exposure. Just be sensible, and only shift it in the direction of *smaller* apertures (larger numbers), which give still more d-o-f. If you shift the program the wrong way, the aperture numeral blinks to warn you that there will not be enough depth of field to encompass the two chosen subjects.

Special Functions

Perhaps the term "useful functions" has exciting connotations in Japanese. It certainly sounds dull in English, yet this is how Canon has chosen to label some of the most fascinating aspects of the Elan/100. To do them justice, I have (immodestly) renamed these features the "Special Functions." Most of them are clever ways of modifying the automatic exposure settings of the camera. There is also a method of accessing a hidden level of the Elan/100's programming, so you can alter some of its fundamental operating parameters. In a sense, all of the Special Functions offer ways to customize the Elan/100 to suit the needs of experienced photographers. I suggest that you master the nuances of the Image Zone and the Creative Zone before delving into these relatively sophisticated matters.

Autoexposure Lock

One of the simplest of the Special Functions is the AE Lock, controlled by a small button marked with an asterisk. The button is located near the upper right corner of the camera back, conveniently close to the photographer's right thumb, whether the Elan/100 is held horizontally or vertically. By pushing the AE Lock Button with your finger *off* the Shutter Button you "lock" the exposure settings at their current values. An asterisk appears on the viewfinder LCD to indicate that the AE Lock is in place.

According to Canon, the AE Lock is intended for "situations when there is extremely strong contrast between the subject and background or when a bright light source or highly reflective object is located in the picture." In other words, you lock onto the main

Exposing for a light-colored subject against a bright sky can be difficult. For best results, use the Partial Metering mode to meter an area close to 18% reflectance. Then, use Autoexposure Lock to hold the exposure settings while the photograph is recomposed. Photo: Bob Shell

subject in tricky scenes that might fool the Elan/100's lightmeter. Although the AE Lock works with any metering pattern, it is most compatible with Partial metering, which lets you see exactly what part of the image you're reading. Each time you press the Lock Button, a new meter reading is taken and locked.

Normally, the lock remains in force until the picture is taken, even if you remove your finger from the AE Lock button. There are, however, some exceptions. If you touch neither the Shutter Button nor the AE Lock Button for about six seconds, the viewfinder LCD panel disappears, taking the AE Lock with it. The Lock also vanishes if you change operating mode. Speaking of which, you can only use this feature in the AE modes of the Creative Zone, i.e. Program, Shutter Priority, Aperture Priority, and Depth-Of-Field Program. It would make little sense to lock your own Manual exposures, after all. And Canon wisely assumes that the tyros of the Image Zone don't know enough to override the camera's automation.

If the Elan/100's film advance system is set for Single Exposure, the AE Lock cancels after that exposure is made. In the Continuous mode, the Lock remains for an entire series of exposures, cancelling when you lift your finger from the Shutter Button.

Perhaps "lock" is too absolute a term for what this control actually does. Let's say you are using the Program AE mode and have locked an exposure of 1/60 second at f/4. Even with the Lock in place, you can still activate the Program Shift function by turning the Main Dial. So the Locked exposure can easily become 1/30 at f/5.6, or 1/125 at f/2.8, etc. These settings give the same amount of exposure but they are not identical in effect.

More surprisingly, the Exposure Compensation function (see below) also works on locked exposures. With a turn of the Quick Control Dial, you can alter the f/stop, shutter speed, or both, depending on the AE mode. This changes the amount of exposure by up to 2 EV, apparently defeating the purpose of the AE Lock.

This provision is more logical, however, than it first appears. Remember, you are locking onto the main subject which may not be the proverbial medium gray color. Once locked, Exposure Compensation lets you adjust for the brightness of the subject, by adding exposure for brighter subjects and subtracting exposure for darker ones. (Again, see the Exposure Compensation section for details.) This kind of fine-tuning is just what the Special Functions

are for. Finally, the AE Lock button has other hidden functions, as you will discover by reading the rest of this chapter.

Exposure Compensation

The Exposure Compensation feature allows you to fine-tune the meter reading in any Creative Zone autoexposure mode. As mentioned earlier, compensation is sometimes necessary with an unusually light or dark subject. On its own, the Elan/100's metering system (and virtually all others) will try to render subjects as medium gray, thereby making dark subjects too light and light ones too dark. This is not usually a problem if the subject is part of a scene that contains a wide brightness range. But if you take a closeup of a snow-white cat, or of a jet-black dog, prepare to be surprised by your newly gray pet.

Even with a more typical subject, contrasty lighting can throw off the meter reading. A common example is a spot-lighted circus performer. If the scene contains a large dark background and a small, brilliant spot, that trapeze artist will be totally overexposed. In the same way, a backlighted subject will sometimes be underexposed, as the meter is overly influenced by the bright background.

Evaluative metering compensates for contrasty light if it correctly identifies what part of the scene is most important, a task that is quite difficult when the main subject occupies only a small part of the scene. With experience, you learn when to trust Evaluative metering and when to override it. By now, it should be clear that the Elan/100 provides several ways to do so, including Exposure Compensation. All of these methods are best employed with Partial metering, so that you know exactly what the meter is reading.

To use Exposure Compensation, first set the Command Dial to the desired Creative Zone AE mode. Then set the Quick Control Switch to I (on). Touch the Shutter Button to activate the meter so that both f/stop and shutter speed values are shown on the LCD panels. The ubiquitous numerical scale on each LCD will be pointing to its central, neutral position. To increase exposure, use your thumb to turn the Quick Control Dial clockwise; twirl it the other way to underexpose. The range is plus/minus 2 EV, displayed in 1/2-EV increments.

Once you have chosen the desired degree of compensation, you may return the Quick Control Switch to O (off) to prevent any accidental changes. Actually, I seldom find this necessary. I prefer to leave the Switch at I, so the compensation can be adjusted as needed. There is little chance of mistaking the set value with the lighted viewfinder LCD staring you in the eye. In the Aperture Priority AE and Depth-Of-Field AE modes, the Exposure Compensation system varies the shutter speed; in Shutter Priority AE, it changes the f/stop; and in Program AE it adjusts both settings.

Flash Exposure Compensation

The same button used to set the Metering Mode also actuates Flash Exposure Compensation, a function that is only available in the Creative Zone. To use it for this purpose, first set the Quick Control Dial Switch on the camera back to the operating (I) position. Then press the Metering Mode/Flash Exposure Compensation button and simultaneously turn the Quick Control Dial in either direction. A lightning bolt/plus/minus symbol appears on the top-deck LCD panel above a numerical display that ranges from -2 to +2.

The display represents the Flash Exposure Compensation range of -2 to +2 EV, in 1/2-EV increments. A pointer below the scale moves to the plus side when you turn the Quick Control Dial clockwise and to the minus side when you turn it the other way. When you have dialed in the desired degree of compensation, flick the Quick Control Dial Switch back to off (O) to lock in the setting. The lightning/plus/minus symbol remains on the LCD as a reminder that flash compensation has been set.

The numerical scale remains visible on the LCD at all times in every Creative Zone mode except Manual exposure. That's because it is used for ambient-light exposure compensation as well as flash compensation. Somewhat confusingly, the scale

↻ **Many photographers intentionally underexpose transparency film by 1/2 stop for better color saturation. In this case, photographer Bob Shell used the Elan's exposure compensation feature to produce this perfectly exposed 35mm slide.**

normally displays the amount of ambient light compensation, *not* the amount of flash compensation that has been chosen. To find out the latter, simply press the Flash Exposure Compensation Button and the scale will display it.

Note that this compensation is only available with the Elan/100's built-in flash. It affects the amount of light that the flash emits but does not change the camera's f/stop or shutter-speed settings. For complex exposure situations, you can even combine Flash Compensation with ambient-light Exposure Compensation. The Elan/100's Flash Compensation system does not operate, however, with external flash units, even if the flash-compensation icon is shown on the LCD panel.

Having explored how flash exposure compensation works, we should examine *why* you might find it useful. As discussed in the previous chapter, the built-in flash can operate as a source of fill light or as the main illumination for an interior scene. In either case, you may prefer a little more or less light than the camera regards as "normal." Fill flash, in particular, depends on a delicate balance between flash and existing light. Too much fill, and your subject looks unnatural; too little, and the skin tones are lost in the shadows. With experience, you learn to use Flash Compensation to harmonize image contrast with the exposure latitude of the film in use.

When employing the flash for overall illumination, contrast tends to be reasonably low. You still may use flash compensation, however, to control the brightness range. In general, color-negative films have more latitude on the overexposure side, so Flash Compensation can add light to open up the shadows without blowing out the highlights. Conversely, color-slide films favor slight underexposure; a toned-down flash will avoid overly "hot" highlights and also increase color saturation. Despite the DX film-coding system, the Elan/100 does not "know" what kind of film it contains—Flash Compensation is one way to tell it.

Decreasing flash output slightly with the flash compensation feature gave this photograph a dark, sultry look. Photo: Bob Shell

Manual Film Speed Setting

Turning the Command Dial clockwise beyond the Creative Zone, you come to four settings marked in black against a silver background. These are not exposure modes, but functions that allow more personal control of camera operations.

The first member of this quartet is the Manual Film Speed Setting function, marked ISO on the Command Dial. As you may know, these initials identify the International Standards Organization, one of whose tasks is to set standards for film speed. When you turn the Command Dial to ISO, the top-deck LCD displays the current ISO number, set by the DX code of the film cartridge in the camera. All DX settings from ISO 25 to 5000 can be accommodated by the Elan/100. The ISO number is not normally visible on the LCD; for extra-important jobs you might want to check it

each time you load a new roll. On the other hand, erroneous DX codes are mighty rare.

If you wish, the DX-set film speed can be overridden easily. With the Command Dial at ISO, turn the Main Dial in either direction to adjust the ISO speed in 1/3-EV increments. When moved clockwise, it increases the speed; turned counterclockwise, the speed decreases. The manual film-speed range is ISO 6-6400, which is even greater than the DX range. Your setting will remain until you change it, or until the next DX-coded cartridge is loaded into the camera.

A word of advice if you are about to shoot an entire assignment on film that works best at a non-DX setting: Cover the DX code on each cartridge with a piece of tape, so you only have to input a manual film-speed setting for the first roll. A small drawback: an ISO reminder symbol will blink on the LCD, as it does whenever a non-DX cartridge is used. (Examples of the latter include special-purpose films—infrared, copy, push-process—and those made in some Third World countries.) For safety's sake, I wish the flashing ISO symbol also appeared when a manual setting was used to override a DX-coded cartridge. (For a more elegant way to defeat the DX system, see Custom Functions below.)

Many photographers like to rate color-transparency films a little higher than the DX setting for maximum saturation (although some current films are so saturated they no longer require this treatment). Conversely, color-negative film often yields the finest grain at a slightly lower film-speed. And with black-and-white or color film of various kinds, you may set a much higher ISO speed for push-processing. Most of these alterations can also be made with the Exposure Compensation feature. A possible advantage of using the ISO setting is that the changes are available in 1/3-EV increments, rather than 1/2-EV, allowing adjustments such as +1/3 EV or -2/3 EV. Also, if you want to push film by more than two stops, changing the ISO setting is the only way. On the other hand, the Exposure Compensation setting is displayed on both LCD panels as a highly visible, constant reminder of its operation.

Multiple Exposure Function

The next position of the Command Dial is marked by a pair of over-lapping boxes. This signifies the Multiple Exposure function, which allows you to create several images on the same frame of film. When the dial is set to this position, a similar overlapping-box symbol appears on the top-deck LCD, along with the numeral 1.

If you now turn the Main Dial clockwise, the displayed number increases to 2, 3, 4...all the way to 9. The numeral you set corresponds to the number of exposures that will be taken on the current frame. Turn the Command Dial to any Creative Zone mode and you are ready to make a series of exposures. The multiple-exposure numeral remains on the LCD in place of the frame number. You can easily tell the difference, because the M-E numeral lacks the brackets that usually surround the frame number. And if you miss that little hint, the overlapping-box pictogram serves as an additional reminder.

The Creative Zone modes operate normally during a Multiple Exposure series. In other words, they do not attempt to adjust the exposure settings for the number of images to be taken. Such adjustments are often necessary, and they can be made easily with the Exposure Compensation function in the Program AE, Aperture-Priority AE, Shutter-Priority AE, and Depth-Of-Field AE modes.

As a rule of thumb, when making two exposures on a frame, each needs to be set for -1 EV. Likewise, three exposures require -1.5 EV, and four exposures need -2 EV each. This is the outer limit of the Exposure Compensation function, so when making a series of five exposures or more, use the Manual exposure mode. In the real world, exposure requirements vary with subject brightness and the amount of overlap between exposures. An extreme example: You make nine images, with no overlap, against a jet-black background. No compensation should be necessary! A more common approach is to use a zoom lens to superimpose two images of the same subject, one full-length, and the other full-face. In this case, you might want to make the head shot lighter than usual, so it will serve as an attractive background.

After you make the first exposure in the series, the M-E numeral counts down to show the number of exposures left and the over-lapping boxes start to blink. The countdown and the blinking continue with each succeeding frame until the series is completed.

Then the numeral is replaced by the normal frame counter, the boxes disappear, and the film advances to the next frame.

Ah yes, I know what you're thinking. What if nine frames aren't enough? All you have to do is set the Multiple Exposure function to nine, and stop after you have taken the first eight pictures. Turn the Command Dial back to the M-E position and set the numeral back to nine, or whatever other value you wish. In theory, you can keep up this eight-frames-and-reset series indefinitely. As long as I don't have to look at the results...

In case you change your mind at any point, there are two ways to cancel the Multiple Exposure function. One method is return the Command Dial to the M-E position and twirl the Main Dial counterclockwise until the M-E numeral is back at one. A simpler way is to turn the Command Dial until it reaches any of the Image Zone positions. The overlapping boxes immediately disappear from the LCD, and the Elan/100 is back in normal operation.

Auto Bracketing

Continuing our tour of the Command Dial, we come to the logo AEB, representing the Auto Exposure Bracketing function. This features lets you take three pictures in quick succession, with the exposure varied by an amount that you select. The "Auto" in the title refers to fact that the bracketing is done automatically; the function is available in all Creative Zone modes, including Manual Exposure.

When you dial in this function, the number 0.0 appears on the top-deck LCD, above the letters AEB. Below them is the familiar multi-purpose numerical scale, with markings from +2 to -2. As you rotate the Main Dial clockwise, the AEB numeral changes with each click, from 0.0 to 0.5, 1.0, 1.5, and finally 2.0. Simultaneously, a pair of markers beneath the scale adjust to indicate the same exposure increments on the plus and minus sides. The number you set represents the amount of exposure compensation, in EV (exposure value) units, commonly referred to as "stops" or "steps."

Once the AEB increment is set, you rotate the Command Dial to the Creative Zone mode of choice, which determines how the bracketing operates. In Program AE, both the aperture and the

In extreme lighting conditions, using the Auto Bracket feature will ensure that you bring home the best possible photograph. Photo: Paul Comon

shutter speed are varied. In Shutter-Priority AE, only the f/stop changes. And in Aperture-Priority AE, Depth-Of-Field AE, and Manual, only the shutter speed is varied. In any mode, the AEB symbol and scale remain visible on the top-deck LCD.

When you push the Shutter Release Button, three exposures are taken, even if the film-advance function is set to Single Exposure. They are made in order of increasing exposure—under,

normal, then over. Let's say you start with an indicated exposure of 1/60 at f/4, and the AEB set at 1 EV. In Program AE, the exposure series will be 1/90 at f/4.5, 1/60 at f/4, and 1/45 at f/3.5. Turn to Shutter-Priority AE, and you get 1/60 at f/5.6, f/4, and f/2.8. In the other three Creative Zone modes, it is f/4 at 1/125, 1/60, and 1/30. Even if you lift your finger from the Shutter Release Button after the first exposure, all three will be made.

Unlike the Multiple Exposure function, Auto Bracketing doesn't self-cancel after each use. It remains in force until you cancel it or remove the film cartridge. Like Multiple Exposure, AEB can be nullified by dialing its value back to zero or by moving the Command Dial to an Image Zone mode. It does *not* cancel, however, when the dial is moved to the Lock (off) position. Auto Bracketing is only intended for ambient-light exposures; it is automatically defeated when you flip up the built-in flash.

There is even a way to bracket in one direction only by using AEB in combination with Exposure Compensation. Perhaps you are concerned that the Elan/100's TTL light meter may underexpose a backlighted portrait. In this particular situation, the metered exposure may prove to be correct, but there is no real chance of overexposure. So you set the Exposure Compensation to +1 EV, and the AEB to 1 EV. This combination shifts the exposure series by one stop, so it effectively becomes normal, +1 EV, +2 EV, as indicated on the LCD numerical scale. Naturally, this method works with any exposure increment, and in either direction from normal.

Auto Exposure Bracketing is useful for fine-tuning the "look" of color-transparency film. Sometimes a variation of only 1/2 stop makes a significant difference in color saturation, and the amount of detail visible in highlight and shadow areas. More than one exposure in the series may prove to be "right," depending on the final use. A denser image might project perfectly, while a lighter one is better suited to magazine reproduction.

Get in close for a more interesting composition and to show off detail. ⇨
The striking label on this weathered seed box was worth bending down to photograph. Photo: Bob Shell

Such fine gradations are less effective with black-and-white or color-negative films, which tend to have greater exposure latitude. Here, a bracketing increment of 1 EV is more appropriate. And for those rare situations that are totally baffling, a 1.5 EV or 2 EV bracket is the equivalent of a quarterback's "Hail Mary" pass. The bracket may not produce exactly the desired result, but it's better than doing nothing.

Custom Functions

Like any good story teller, I've saved the best for last. The final position on the Command Dial is labelled CF, for Custom Functions. This innocuous name signifies a smorgasbord of hidden options which let you personalize the Elan/100 to suit your own preferences.

With the Command Dial at CF, the top-deck LCD shows a small CF logo, above which is a large CF 1 and the numeral 0. CF 1 refers to the first of the seven Custom Functions, and 0 indicates that it is in the factory-set position. To change the value of CF 1, press once on the AE Lock button and the accompanying 0 becomes a 1. A second push of the AE Lock returns CF 1 to the standard 0 position. To alter a different Custom Function, turn the Main Dial in either direction. It is continuously variable, with each clockwise click accessing a higher number and vice versa. Each CF can be set independently to either the factory (0) or user-selected (1) position, with no effect on the others.

The Custom Functions operate when the Elan/100 is set to any of the Creative Zone modes. If any of the Functions have been changed to the user-set (1) position, the small CF logo is visible on the LCD. When you turn the Command Dial to the Image Zone, the logo disappears because all systems operate in their factory-set positions. Your programming has not been lost, however, and it will again become operative when you return to the Creative Zone. The CF settings are also preserved when the camera is turned off.

CF 1 Automatic Rewind Cancellation
Normally, the film rewinds automatically at the end of each roll. The alternate setting of CF 1 defeats this feature so that rewind is only initiated when you press the Film Rewind Button on the

camera's side. Until you do so, the frame number blinks on the top-deck LCD.

The motorized rewind system of the Elan/100 is rather quiet, but it is not as hushed as the film-advance, focusing, and shutter-release mechanisms. When shooting in a noise-sensitive environment, such as a theater, you might not want rewinding to begin unexpectedly. (Remember, there is no frame counter in the viewfinder.) With CF 1 in place, you know the roll has ended because the Shutter Button immediately stops operating. This gives you the chance to tuck the Elan/100 into a camera bag or other sound-muffling device before rewinding begins.

CF 2 Second-Curtain Flash Sync

This function is useful for photographers who combine flash with long ambient-light exposures of moving subjects. In normal practice, the flash fires as soon as the first shutter curtain has completely opened, exposing the entire frame. With Second-Curtain Sync, the flash waits to fire until just before the second curtain starts to close.

At high shutter speeds, the distinction means little—who cares if the flash fires 1/125 second sooner or later? When the shutter is open for, say, 1/15 second or longer, the situation changes. Perhaps you have a runner moving from left to right across the frame. If the flash fires first, you have a sharp subject on the left, and a blurred image trailing in *front* of him. Obviously, this makes no visual sense. You want the flash-lighted instant to occur at the end the exposure, creating a bright, main subject, with a blurred image trailing *behind* him. This effect works equally well with built-in or external flash units.

CF 3 DX Cancellation

This is a more sophisticated version of my tape-over-the-DX suggestion, mentioned above. In the user-set position, CF 3 simply ignores the DX code of any film cartridge. The film-speed setting remains at its previous value, whether it was determined by the DX system or input manually. Naturally, you are free to change the ISO setting to suit your preference for any particular film; that's the whole purpose of this Function.

In fact, CF 3 is neater and simpler than my method in almost every way. The only problem is that it is not idiot-proof. Most of

us are so used to the DX system that we don't automatically check the ISO setting when we change film types. The CF logo on the LCD may serve as a reminder, but it has at least seven potential meanings. CF 3 would be perfect if only it caused that annoying ISO signal to blink on the LCD, as it does in my low-tech version.

CF 4 AF Auxiliary Light Cancellation
The AF Auxiliary Light shines momentarily in low-light and/or low-contrast situations, projecting a target that helps the AF system to lock onto the subject. Particularly at close range, the light allows the AF system to function in extremely dim surroundings. So why would you want to cancel such a useful feature?

Canon suggests an altruistic reason: If many people are photographing the same subject from various angles, your AF Light may show up in someone else's pictures. By cancelling the light, you prevent this possibility. That's a noble thought, yet I am not convinced that it is practical. First of all, unless the other photographers all cancel their AF Lights, they will still appear in *your* pictures. Also, without the AF light, your photos are likely to be less than optimally sharp. It is the rare photojournalist who puts his competitors' interests ahead of his own.

A more likely scenario is that you are shooting quietly in low light, and simply prefer not to be noticed. While the beam emitted by the AF Light is quite unobtrusive, the light source itself is clearly visible to anyone looking in the direction of the camera. So for candid assignments, by all means use CF 4. And if that makes the AF system fumble, switch over to Manual focusing.

CF 5 Depth-Of-Field Preview
In the previous chapter, I wrote at some length about the Depth-Of-Field AE mode and other methods of controlling image sharpness. As I said, the Elan/100 does not have a conventional d-o-f preview control. It does, however, have a most unconventional one.

CF 5 assigns the d-o-f preview function to the AE Lock button without disabling the button's primary mission. In other words, by pushing this button you lock the automatically set exposure and physically stop down the lens to the chosen aperture. That's a complex combination and it takes a little getting used to.

The AE Lock function continues to work normally. When you press the Lock button, the f/stop and shutter speed values are

Use the depth of field preview to check that important details in the foreground and background of the photograph are in focus.
Photo: Paul Comon

frozen and an asterisk symbol appears in the viewfinder. The settings remain this way until the picture is taken unless you remove your fingers from the AE Lock button and the Shutter Button for six seconds. Then the meter shuts off, simultaneously cancelling the AE Lock.

With CF 5 in effect, the lens stops down as you push the AE Lock button and stays that way as your finger remains on the

button. The viewfinder darkens, of course, and the relative sharpness of various subjects appears (approximately) as it will in the final image. If you like what you see, press the Shutter Button to take the pictures.

You are also free to preview other f/stop settings by turning the Main Dial in either direction. Clockwise movement widens the aperture, counterclockwise makes it smaller (except in Aperture Priority AE, which works in the opposite direction). In any case, the shutter speed also adjusts so the amount of exposure is unchanged. After all, the AE Lock is still in force.

If you release the AE Lock button, the lens returns to full aperture and the viewfinder brightens appreciably. But the exposure settings are still locked! So beware of casually flicking the button to check depth-of-field. If you do so and then unthinkingly aim the Elan/100 at a different subject, you're likely to get an incorrect exposure.

To avoid confusion, I tend to use CF 5 in the Manual Exposure mode. With no auto exposure, there's no AE Lock to worry about. The light reading is made an instant *before* d-o-f preview is activated and held in the camera's memory, so the Exposure Confirmation system is not fooled as the lens stops down. In fact, you can match the arrowheads with complete confidence, no matter how dark the viewfinder image appears. If the illumination changes, however, be sure to release the AE Lock/Depth-Of-Field Preview button, then press it again. This allows the Elan/100 to make a new light reading.

CF 6 Beeper Off

In normal operation, a beeping tone sounds during self-timer operation. A symbol on the LCD confirms the beeper's status, which hardly seems necessary. CF 6 lets you switch off this audible confirmation.

The advantage of the beeper is that it keeps your subjects looking at the camera. Without the sound, there is no indication of the timer running until the last few seconds when the AF Auxiliary Light blinks rapidly. The beeper is not very loud and in most circumstances I leave it on. But the chirping might be objectionable in a museum or theater, and it is definitely not suitable for candid shooting.

CF 7 Mirror Up

The last Custom Function is a gem. CF 7 raises and locks the mirror as soon as the Self-Timer is actuated. The picture is taken ten seconds later, as usual. In the preset position, the mirror rises just before the picture is taken.

Although the Elan/100's mirror causes very little vibration, why not have that tiny shock occur as long as possible before the exposure? This is a particular advantage for high-magnification work, such as macro or super-telephoto photography. CF 7 does not affect the action of the mirror during non-timer shooting. I can see no down side to keeping it in the on ("1") position at all times.

Quartz Date Back

An alternate version of the Elan/100 is available with a Quartz Date Back capable of imprinting information near the lower-right corner of the image. Before using it, push the tiny Select and Set buttons to input the year, month, date, and hour, all visible on a small LCD panel.

By pressing the adjacent Mode button, you can determine how (and if) this information is to be displayed. The standby position, indicated by a row of dashes on the LCD, is no data imprinting. Pushing the Mode button cycles the Date Back through its options: Month-Date-Year; Date-Month-Year; Year-Month-Date; and Date-Hour-Minute. To prevent confusion, a small M denotes the month, and a colon separates the hour and minute numerals. Power is supplied by a separate three-volt battery in the camera back. The Date Back is not removable or interchangeable with the standard Elan/100 back.

Canon Flash Units

The Elan/100 appeals to a wide range of photographers, from novices to professionals. Some never move the Command Dial from its Full Auto position. Others master every subtlety of the camera's many modes. Even at the same level of sophistication, subjects and shooting conditions vary considerably. So it shouldn't be surprising that Elan/100 users have diverse requirements for flash photography.

As a step toward meeting these needs, Canon incorporates a flash unit into the Elan/100 (and some other SLR models). There are several advantages to this "pop-up" flash, as noted in previous chapters. It is small, lightweight, convenient, and fully integrated with all camera functions. The built-in flash even has a zoom head which automatically matches the light output to the focal length in use. Best of all, the flash is part of the Elan/100, so it is always available when you need it.

Of course, this tiny unit has its limitations. While it has enough power for moderate-size rooms, you can't illuminate a cathedral with a candle. With ISO 100 film, the guide number for a 28mm lens is 12/40 (feet/meters); at the 80mm setting it's 17/60. So with a 28mm f/2.8 lens (or equivalent zoom), the approximate maximum flash distance is 14.3 feet, or 4.3 meters. That may be fine for a birthday party, but what about a wedding? Group portraits often have to be taken from a considerable distance and you don't always want to use the lens wide open.

Beyond raw power, there is the question of flexibility. The built-in flash is so close to the lens axis that it cannot be used properly with some large lenses, particularly at close shooting distances. Try it, and you get a strange semicircular shadow at the bottom of the frame. Red-eye can also be a problem when the flash is near

Stunning portraits like this one don't require a fully-stocked professional studio. Several Canon Speedlites, a basic understanding of lighting and some practice can produce excellent results. Photo: Bob Shell

the lens, even if the red-eye reduction feature is used. And there are some wonderful techniques that are simply beyond the realm of a built-in unit, such as bounce flash, true stroboscopic output, and shadowless "ring" lighting of close-up subjects.

All of this is a long-winded introduction to the potential need for external flash units. Canon offers five "dedicated" models that not only fit EOS cameras, such as the Elan/100, but fully integrate with each SLR's operation. There is a continual exchange of information, sort of an electronic "conversation" between camera and flash, to ensure that their functions mesh seamlessly. This means, minimally, that the flash is cycled and set to the right zoom position that the shutter speed is no higher than 1/125 second and that the f/stop is at a reasonable value. In the more advanced exposure modes, the data flow is even more intense. This is just not a job for the old flash gun that's sitting in your closet under an inch of dust.

Speedlite 200E

This is the baby of the Canon system, generally used with non-flash versions of the inexpensive EOS Rebel series cameras. The 200E is admirably small (2.5x1.6x4.1 inches; 64x41x104mm), lightweight (4.6 oz. or 130 gm, without batteries), and quite inexpensive. Basically, it is a scaled-up version of the Elan/100's built-in flash, with an ISO 100 guide number of 20/66 (meters/feet). The angle of coverage is suitable for lenses as wide as 35mm, or 28mm with the optional Wide Adapter 200E. And there is no zoom feature, as signified by the lack of a "Z" in the model designation.

Used with a 35mm focal length, the 200E offers a maximum working distance about 60% greater than the built-in flash. This advantage virtually disappears with longer lenses, due to the lack of a zoom head on the 200E. Switch to a 28mm lens and the Wide Adapter soaks up most of the 200E's potential advantage.

The flash reflector of the 200E is positioned several inches above the lens axis, so it should be usable with virtually all EF lenses. This elevated position also reduces red-eye, without the need for an annoying pre-flash. That's probably not enough to recommend the 200E, which lacks bounce capabilities and the A-TTL (advanced through-the-lens) control capabilities of more sophisticated units.

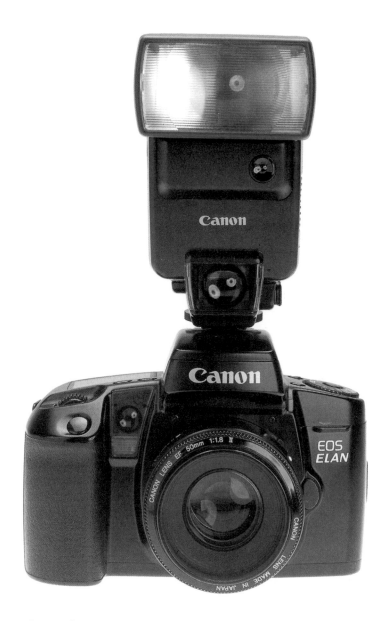

The EOS Elan with 430EZ Flash Unit

Speedlite 300EZ

To continue the family analogy (which I promise not to extend further), the 300EZ is like a teenager, literally bursting with energy. In a flash unit, such enthusiasm translates to considerably enhanced light output. The ISO 100 guide number with a 28mm focal length is 21/70 (meters/feet); at 70mm, it's 30/98. These figures are about 75% higher than those of the built-in flash with lenses of comparable focal length. So, let's revisit the example given above. When shooting a wedding with a 28mm f/2.8 lens, the integral flash limits you to a maximum distance of about 14 feet. Switch to the 300EZ, and you can back up to 25 feet to include the entire wedding party. Even with a slow zoom lens, the 300EZ provides enough power for comfortable operation.

The Canon Speedlite 300 EZ

Power isn't everything, of course, and the 300EZ also offers a reasonable amount of finesse. For example, there is the zoom head, which automatically adjusts to lens focal lengths from 28mm to 70mm. A powerful AF Auxiliary Light allows the Elan/100 to focus accurately in low light and/or low-contrast situations, over the entire flash operating range. The 300EZ supports both A-TTL and standard TTL metering (as will be discussed in the Speedlite 540EZ section). Other useful features include second-curtain flash synchronization and a limited rapid-fire ("strobe") capability. An

illuminated indicator displays the focal-length setting of the flash head. Unfortunately, the head position is fixed and does not offer bounce lighting.

Despite its power, the 300EZ is surprisingly compact. It measures 2.6x4x3.5 inches (66x100.5x89mm), and weighs 7.8 oz. (220 gm) without batteries. The 300EZ may lack some of the control flexibility of the larger units, yet it is a significant step up from the built-in flash.

The Canon Macro Ring Lite ML-3 which is specially designed for closeup photography. Photo courtesy of Canon.

Macro Ring Lite ML-3

Unlike the general-purpose Speedlite models, the Macro Ring Lite ML-3 is a highly specialized flash unit dedicated to close-up photography. In fact, it is intended for use only with the EF 50mm f/2.5 Compact Macro and EF 100mm f/2.8 Macro lenses.

The ML-3 consists of two sections connected with a coiled cord. The Flash Unit, shaped like a doughnut, attaches to the front of the lens. This part contains two curved flash tubes and two miniature focusing/modeling lamps, all behind a frosted panel. It weighs only 4.9 oz. (140 gm) and measures 4.2x1x4.9 inches (106x24.5x123mm).

The second section is a black box called the Control Unit, which contains the batteries and controls. At 7.9 oz (225 gm, without batteries), it easily mounts on the hot shoe of the Elan/100. Dimensions are 3x4.2x2.4 inches, or 74x106.5x60.5mm.

Raw power is not vital for macro work, and the ML-3 has a relatively modest ISO 100 guide number of 11/36 (meters/feet). Considering that you may be working at subject distances of a few feet or even closer, aperture settings are typically quite small. Extra power would probably be wasted.

The two flash tubes are generally used together to create shadowless lighting of postage stamps or other flat subjects. Either tube can also be employed separately for a more dramatic effect with three-dimensional or textured subjects. In any case, the appropriate guide lamp, or lamps, give you a preview of the lighting setup. They also act as focusing aides for the Elan/100's AF system.

Because the ML-3 is fully integrated with the camera, through-the-lens exposure control is automatic as well. Canon recommends the use of Aperture-Priority AE for optimum control of image sharpness and depth of field. Manual exposure selection is also possible, but only advisable for experienced macro photographers. The TTL reading automatically accounts for subject reflectance, ambient light level, flash-to-subject distance, and lens extension. And the results are not only faster but also probably more accurate than you could obtain with tedious manual measurements and calculations. Three cheers for automation!

Speedlite 480EG

By far the largest and most powerful member of the Speedlite group, the 480EG is clearly intended for heavy-duty professional use. The "G" stands for "grip," a polite way of designating the classic "potato masher" flash design. There's a large, rounded flash head atop a cylindrical body, attached with a clamp to a flat bracket that threads into the tripod socket of the Elan/100. The whole setup measures 11.5x10.1x4.5 inches, or 291x256.5 x114.3mm. A coiled cord connects the flash unit with the camera's hot shoe.

You hold the Elan/100 with your right hand and the 480EG with your left. And a few chin-ups might be in order, for the flash weighs

37.3 oz. (1065 gm), minus its hefty complement of batteries. The payoff is in power—an ISO 100 guide number of 68/223 (meters/feet), considerably more than any other Speedlite. There is lots of operational flexibility and a design bonus: Because the flash head is relatively far from the lens axis, and offset from it both vertically and horizontally, red-eye should not be a problem. (Trivia fans may notice that Canon Speedlites are usually named for their metric guide number, multiplied by 10. By this rule, the 480EG should be called the 680EG. But it isn't.)

The 480EG offers a choice of exposure-control methods, including two types of autoexposure. Used with the Elan/100, the preferred approach is TTL flash metering, available in the camera's Program AE, Shutter-Priority AE, and Aperture-Priority AE modes. For less sophisticated cameras, the 480EG is also equipped with an external sensor to provide non-TTL autoexposure. The decision between the two modes is really a no-brainer because TTL metering provides more flexibility and far greater integration of flash and ambient light.

A control panel on top of the flash head lets you select the exposure mode and input the ISO film speed. The latter is required for external-sensor autoexposure, a mode that does not access the Elan/100's film-speed information. Another interesting top-panel choice is manual exposure, complete with a flash-output level selector. When using more than one flash unit, you generally want to limit the output of at least one unit to create the desired lighting ratio.

In fact, a small socket on the flash head accepts the accessory Slave Unit E to allow one or more 480EG units to be used for wireless off-camera lighting. The slave unit operates at distances up to 75 feet (23 meters), and has a 110-degree angle of reception. This wireless multi-flash setup does not, however, allow TTL autoexposure. (For TTL multi-flash operation, the range of accessories discussed in the Speedlite 540EZ section work with the 480EG as well.)

The 480EG does not have a zoom head but it does offer a method of accommodating wide-angle or telephoto lenses. Provided with the unit is the Panel Adapter 480EG, along with the Wide Panel 480EG-20 and the Tele Panel 480EG-135. As the names suggest, the Wide Panel provides even illumination with lenses as wide as 20mm, while the Tele unit narrows the light output to match focal lengths of 135mm or more.

Another way of providing soft, wide-angle lighting is with bounce flash. To achieve this effect, the 480EG's flash head can be tilted up to 90 degrees, providing full bounce capabilities for horizontal images. When you turn the camera for vertical shots, you can rotate the flash head for bounce lighting. The rotation continues for a full 295 degrees, which might seem a bit excessive. Remember that the 480EG can be used for off-camera flash simply by detaching the clamp from the bracket. Whether placed on a tripod, a shelf, or some other surface, the 480EG can rotate to point the light where you want it.

For extended shooting sessions that require quick flash recycling, the optional Transistor Pack E is the logical power source. In its simplest form, the Pack utilizes the supplied Connecting Cord ET and Battery Magazine TP. This setup uses six C-size alkaline batteries to provide 100-700 flash exposures at recycling times between 0.2 and 17 seconds. (Obviously, both the number of shots and the recycling intervals depend on the operating mode, subject reflectance, and flash-to-subject distance.)

A more elegant arrangement uses the optional Transistor Pack E NiCd Set, consisting of the NiCd Pack TP, its companion NiCd Charger TP, and a connecting cord. This rechargeable set offers 90-600 flashes at intervals from 0.2 to 6 seconds. When shooting a wedding, for example, it's probably better to have the slightly smaller number of flashes with a far faster average recycling time than the alkaline pack. On the other hand, the NiCd pack requires 15 hours to recharge, so it's probably a good idea to have two of them and a set of C cells just in case you're overcome with photographic inspiration.

Speedlite 540EZ

The Canon 540EZ Speedlite

Although it is slightly less powerful than the 480EG, the 540EZ is really the top of the Canon Speedlite range. It is the newest model in the group (replacing the 430EZ), incorporating every operating feature and convenience that could be crammed into a relatively compact shoe-mount flash. Compared with the 480EG, the 540EZ is almost tiny, at 3.1x4.5x5.5 inches (80x112x139mm). Weight is a reasonable 14.2 oz. (405 gm) without batteries. Because this is a

Canon 540EZ Speedlite

zoom-head unit, the guide number varies with the lens focal length, from 28/92 (meters/feet) at wide-angle to 54/177 at the telephoto setting.

In my opinion, the 540EZ is a perfect companion for the Elan/100 and should be seriously considered by any photographer who does a lot of flash work. To see why this is so, I am going to explore the 540EZ's operation in far more detail than the other Canon flash units.

Getting Ready

Sliding open the battery cover on the side of the 540EZ reveals a compartment that holds four AA-size batteries. The standard power source is a set of alkaline-type cells which yield from 100 to 700 flash bursts at recycling times of 0.2-13 seconds. In general, the maximum number of flashes and the shortest recycling times are provided in the A-TTL mode; the fewest flashes and longest times are for full-power manual operation. Four AA-size NiCd cells can also be used for 45-300 flashes at cycling times of 0.2-7 seconds.

Unlike some other manufacturers, Canon approves the use of the new AA lithium cells in the flash unit only, not in any external power pack. And even if you do employ an external power source, there must be a set of functional batteries in the 540EZ as well. In a pinch, a set of manganese ("heavy duty") cells will serve. The external battery packs will be discussed in detail a little later on.

All operating controls are located on the back of the 540EZ, below the large LCD panel. On the lower right is the Main Switch, which has three positions: O (power off); I (power on); and SE (Save Energy). In the latter position, the flash works normally but switches off automatically if the unit has not been used for 90 seconds. To return power in the SE mode, either tap the camera's Shutter Button or press the Ready Lamp/Test Firing Button (mysteriously labelled Pilot) on the flash. When the flash is turned off (either manually or by the SE system), all settings are memorized; they are restored when the unit is switched back on.

Shortly after you turn on the power, the Ready/Test button starts to glow. Push it and the 540EZ fires to confirm that all systems are operating normally. When the ready lamp glows red, the 540EZ is fully charged and all flash modes can be used. In certain low-drain modes, the 540EZ automatically switches to the Quick Firing function and the Ready lamp glows green. These modes include A-TTL mode when the Elan/100 is set for Single Exposure film advance and TTL mode when the flash head points either straight ahead or 7-degrees downward. Recycling times in the Quick Firing mode range from 0.2 to two seconds.

Changing Flash Settings
As mentioned earlier, the 540EZ incorporates a motorized reflector that automatically adjusts to the lens or zoom setting from 24mm to 105mm. If you wish, the reflector setting can also be changed manually. Either way, the focal length in use is displayed on the flash's LCD panel. And if you need still more coverage, a pull-out Wide Panel fits over the reflector to spread light output over the angle of view of an 18mm lens. Even with the diffuser panel in place, all automatic control systems remain operative.

When you turn on the flash, the word Zoom appears on the LCD panel to indicate the Auto Zoom setting. A focal length number is also displayed. To access the Manual Zoom mode, push the Zoom Button until M Zoom is visible, next to the focal-length number. Each subsequent push of the Zoom button moves the M Zoom display one step through its cycle of 24mm-28mm-35mm-50mm-70mm-80mm-105mm, then back to Auto Zoom. The Manual Zoom feature is fine for non-dedicated cameras, which cannot synchronize with the Auto Zoom feature of the 540EZ. With the Elan/100, however, it is easier and safer to keep the flash in Auto

Perfect flash photography is no longer guesswork with the Canon Elan/100's automatic TTL metering and the sophisticated 540 EZ flash. Photo: Scott Augustine/Mayfair Two Studio

Zoom at all times. Unless, of course, you are purposely trying to vignette a flash scene....

For lenses wider than 24mm, engage the Wide Panel by pulling it from the slot just above the flash head and swinging it down over the reflector. With the Panel in place, flash output is spread evenly over the entire image field of an 18mm wide-angle lens. Maximum flash distance is somewhat restricted, however, because the effective guide number drops to 16/53 (meters/feet).

When the Wide Panel is in use, the Zoom function does not operate. Also, the Panel should only be used with the flash head in the straight-ahead (normal) or seven-degree downward position. There is simply no point in diffusing a beam of light that is

In this photograph taken with TTL automatic flash, the background appears dark due to light falloff because the flash was set to expose for the subject. Photo by Scott Augustine/Leichtner Studios

going to be bounced off a wall or ceiling. If you try to do so, the entire LCD panel will blink as a warning that you should repent your misguided efforts. (For a most useful exception to this rule, see the Bounce Flash section below.)

By the way, it is wise to use a gentle hand with the Wide Panel, which can be broken off by excessive force. If you do so, the Zoom button will cease to operate. To restore it, slide the Main Switch from O to SE while pressing both the Zoom button and the Flash Mode button. This restores Zoom operation, but the 540EZ will still need the tender attention of a Canon service station.

Used by itself, the Flash Mode button selects the firing mode of the 540EZ. Each push of the button advances the flash to the next mode, in this order: A-TTL/TTL (auto flash); M (manual); Multi

(stroboscopic). The two automatic modes share the same setting on the 540EZ because they are controlled by the mode setting of the camera.

When the Elan/100 is set for any Image Zone mode, the 540EZ automatically operates in A-TTL; Manual, Multi, or regular TTL are not available. In the Program AE mode, you have a choice of A-TTL, Manual, or Multi. The other Creative Zone modes allow TTL, Manual, or Multi flash operation. (Depth-Of-Field AE cannot be used with flash.) When the flash head is set to a bounce position, however, the TTL mode is employed, regardless of the camera's setting (even though the LCD panel continues to display A-TTL in those modes that normally use this function). The distinction between TTL and A-TTL will be explored in the next section, along with the mysteries of Manual and Multi operation.

In low light, you may have trouble reading the LCD panel. To remedy this, press the small, unmarked Display Panel Illumination button to the lower left of the LCD. The panel lights up for eight seconds, then the lamp switches off automatically. If you press the button while the panel is lighted, the lamp is doused immediately.

And speaking of low-light/low-contrast situations, the 540EZ has its own AF Auxiliary Light, located just above the flash shoe, to give the Elan/100's autofocus system a little help. This lamp is even more powerful than the one in the camera, providing a working range of 1.7-49.5 feet (0.5-15 meters). It operates only with the Elan/100 set for One-Shot AF, as is the case for all Image Zone modes except Sports, and in all Creative Zone modes, at the photographer's option.

Basic Operation
The easiest way to start working with the 540EZ is with the flash in the A-TTL mode and the head in the forward (normal) position. Set the Elan/100 to any Image Zone mode, or to the Program AE mode. Slide the Main Switch on the flash to I or (better yet) SE. Then point the camera at your subject and push the Shutter Button halfway in. The 540EZ's Pre-Flash Emitter will send out a burst of near-infrared light, which allows the flash to evaluate subject brightness and reflectance. Based on this information, the Elan/100 sets an appropriate f/stop and a flash-sync speed of either 1/60 or 1/125 second. The pre-flash system functions only in A-TTL mode.

At this point, the flash indicator in the viewfinder should be lighted (to show that the flash is ready), and the f/stop and shutter-speed indicators should glow steadily without blinking (to indicate that the exposure will be correct). Now depress the Shutter Release Button completely to take the picture.

Immediately afterward, the Flash Confirmation lamp on the back of the 540EZ will glow for about two seconds, to indicate that the flash exposure was correct. If it doesn't light up, the scene was probably underexposed. This may happen because the subject was less reflective than determined by the Pre-Flash Emitter or because the flash capacitors were not fully charged. (Ready lights tend to go on before the flash is 100% ready because the full output is seldom required.) To be safe, wait a few seconds after the ready light glows, particularly with distant subjects. And to be doubly safe, try moving a little closer.

The same procedure works well outdoors to create fill flash with backlighted subjects. In this situation, the flash output is automatically reduced to keep it from creating an overlighted, "cardboard cutout" effect. One caveat: If the background is very bright, such as a noonday beach, a very small f/stop may be required with the 1/125 second flash-sync speed. With a normal or wide-angle lens, that may create a greater zone of sharpness than you expect. It's a good idea to use the depth of field preview (Creative Function 5) to check for intrusive palm trees growing from the subject's head.

Shutter-Priority AE

Move the Command Dial of the Elan/100 and you change the operation of the 540EZ as well. Only in the Program AE mode, or in the Image Zone, do you get the sophisticated A-TTL system, with its infrared pre-flash function. As stated earlier, the shutter speed is automatically set to either 1/60 or 1/125 second, and the aperture is placed at a value determined by the pre-flash. Each of the other modes works a little differently.

Remember that in available-light shooting, Shutter-Priority AE is the best mode for controlling action. This is still the case with flash, although your top shutter speed is now limited to 1/125 second. And that same speed is available in the Program AE mode with the added benefit of A-TTL. So the only reason for using Shutter-Priority with flash is to choose a slow shutter speed. This might be a good idea if you want to preserve background detail in a

dimly-lighted scene where only the foreground is lighted by the flash. Alternately, a longer speed can create blurred images of moving subjects, juxtaposed with the sharp image made by the flash.

Any speed from 30 seconds to 1/125 may be selected by the photographer and the camera will choose an appropriate f/stop, which is displayed on the flash LCD. Yes, the Elan/100 is doing the choosing, rather than the 540EZ. In fact, the automatically selected aperture is exactly the same, whether the flash is turned on or off. The assumption is that the aperture/shutter-speed combination will give the correct amount of exposure for the ambient-lighted background. Meanwhile, the TTL flash-metering system controls the output of the 540EZ, quenching it when the foreground has been properly illuminated.

This system is identical to that used with the built-in flash. And, if you recall, it is best used to fill the foreground, not to light the overall scene. The reason is simple: Let's say you are shooting in a room that requires an exposure of 1/8 second at f/2.8. Use flash to illuminate that room, with these same exposure settings, and you are likely to have some degree of overexposure. As quickly the 540EZ can be quenched, it still emits a significant amount of light, even where none is needed.

A distance scale is displayed on the 540EZ's LCD panel in the Shutter-Priority AE mode, and in other modes that use TTL, rather than A-TTL, flash metering. The scale has numbers from 1.7 to 60 feet, or from 0.5 to 18 meters, with the unit of measure selected by the photographer. Above the numbers appears a series of dashes to indicate the working range of the flash. Obviously, the maximum distance is greatest when a wide aperture is being used and more limited with smaller f/stop. And keep in mind that the scale refers to the distance from the 540EZ to the foreground subject, which (theoretically) is all the flash will be illuminating.

The Manual and Multi flash modes can also be used with the Elan/100 set for Shutter-Priority AE. These modes will be discussed in their own sections a little later on.

Aperture-Priority AE

The Aperture-Priority mode offers the same flash-mode choices as Shutter-Priority mode. In most situations, the 540EZ will be set for TTL autoexposure, which again is most useful for lighting foreground subjects, whether indoors or outdoors. The difference, of

course, is that the photographer is manually controlling the lens aperture rather than the shutter speed.

That distinction may be more apparent than real, however. As you change the f/stop setting, the shutter-speed automatically adjusts to set the proper ambient-light exposure. Again, this happens whether or not the 540EZ is turned on. The chosen f/stop appears on the flash LCD panel along with the working-distance scale.

In fact, the only real difference between Shutter-Priority and Aperture-Priority flash operation is in the type of warning signals that are displayed. In the Shutter-Priority mode, a flashing maximum aperture value (such as f/2.8) cautions of underexposure, while a blinking minimum f/stop (such as f/22) means incipient overexposure. In either case, the aperture numeral blinks on the top-deck and viewfinder LCD panels of the Elan/100 but not on the 540EZ's display panel. To stop the blinking, you change the shutter speed. In Aperture Priority, it's the shutter speed that winks a warning: 30" (30 seconds) flashing for underexposure, 1/125 for overexposure. The remedy is to alter the f/stop value.

Despite these similarities, Aperture-Priority AE does have its own purpose, the control of subject sharpness through the manipulation of depth of field. With or without flash, the principles are the same: large apertures for shallow d-o-f, small apertures for extensive d-o-f. The most efficient way to accomplish this is by choosing a promising f/stop setting, and then checking the visual effects with the depth-of-field preview button (Custom Function 5). But keep in mind that changing the f/stop also changes the flash range and alters the ambient-light exposure as well. Let's see how.

Imagine that you are making a portrait of a friend sitting on the porch with an overcast landscape behind her. The Elan/100 is in the Aperture-Priority mode; to keep the background soft, you set the aperture to f/2.8. The subject is backlighted, however, so you decide to use the 540EZ for fill-light. Turn it on, and you notice that the closest distance indicated for f/2.8 on the flash LCD scale is 15 feet (with ISO 400 film). Your friend is much nearer than that, and if you blithely fire away, she will be significantly overexposed by the flash. To get proper flash exposure at a more reasonable seven-foot distance, you have to stop down to f/4.5. Checking the d-o-f preview, you find that that setting makes the background a little sharper, but still not too intrusive.

Before taking the picture, you press the Shutter Button partway

in to confirm the exposure settings. The Elan/100 automatically sets the shutter speed to the flash-sync value of 1/125 second. That takes care of the flash-lighted foreground, but notice that the 1/125 numeral is now blinking to warn you that the background will be overexposed. The blinking will stop if you change the aperture to f/11, the proper value at 1/125 second for the overcast background. Now you have achieved correct exposure, but not the visual effect that you wanted.

If all this makes fill flash seem like nuclear physics, you have my apologies. The situation really is not so complex, yet it does require careful attention, even with highly sophisticated equipment such as the Elan/100 and the 540EZ. Just keep in mind that you have, in effect, two separate scenes, the foreground and the background, each illuminated by a different light source. And your range of usable shutter speeds is limited by the camera's flash-sync capabilities.

Here are a few simple tips: If the flash is too strong at the desired shooting distance, pull the Wide Panel over the reflector. In the example given above, this arrangement permits flash exposures as close as five feet, at f/2.8. Although some light will be "lost" around the edges of the image area, that is of little importance. This solution is fine in many cases, but in our example it will still result in a "blown out," overexposed background. A better approach is to use much slower film. At ISO 50, the flash functions as close as five feet at f/2.8, without requiring the Wide Panel. This exposure setting (1/125 second, f/2.8) will overexpose the background by about a stop, which may not be bad. The viewer easily accepts that the outdoor part of a scene is brighter than the indoors. As long as the background is not a white void, the effect can be quite pleasant. If you decide that the background must be properly exposed, stopping down to f/4 will make it so.

Manual Exposure Mode

At this point, we are exploring the Manual Exposure mode of the Elan/100, rather than that of the 540EZ. Although it may seem logical to use a manual camera setting with a manual flash mode, there is no compelling reason to do so. With the Elan/100's Command Dial at the Manual position, you have three flash choices: TTL AE, Manual, and Multi. Only the first of these will be discussed in this section.

With or without flash, in the Manual mode you turn the Main Dial to select a shutter speed and rotate the Quick Control Dial to choose an f/stop. Any combination of values can be set, except that with the flash unit switched on, the maximum shutter speed is 1/125 second. If you have already chosen a higher speed, and then turn on the 540EZ, the shutter speed is automatically lowered to 1/125. The Exposure Confirmation display on the viewfinder LCD shows an arrowhead containing a plus sign for overexposure, one with a minus sign or underexposure, or both symbols for proper exposure. Again, with or without flash, these symbols refer to the ambient-light exposure level.

Therefore, it should be clear that the flash output is intended to illuminate the foreground subject, not the entire scene. TTL flash AE can only limit the output of the 540EZ; it cannot prevent the flash from firing, even when its output will cause overexposure. In this mode as well, the LCD panel of the 540EZ displays the chosen f/stop, and the flash-operating range. The dashes over the distance settings on the scale shift with any change in aperture value.

Using Manual Exposure with flash is appropriate in two types of situation: 1) You want to exert maximum control over depth of field and over the rendition of a moving subject. An example might be a car driving by at dusk in front of a spectacular cityscape. A slow shutter speed, combined with a burst of flash, will emphasize the car's movement. Meanwhile, a careful choice of aperture will determine the sharpness or softness of the brilliant background. And the combination of the two values create an exposure level that renders the background as light or dark as you desire.

Example 2) The background subject is so tricky that you don't trust the Elan/100's AE system to render it correctly. For instance, consider an outdoor portrait at night, in front of a neon-lighted Las Vegas exterior. Manual exposure settings let you choose how bright those lights will appear. In addition, the specific f/stop determines background sharpness, while the shutter speed either freezes or "flows" the motion of the lights. Even in such difficult situations, the TTL automatic metering of the 540EZ can be depended upon to expose the foreground properly, as long as it is within the distance range indicated on the LCD panel. With the camera in Manual, there are no flashing numerals to indicate over- or underexposure of the background. There is just a plus or minus, which

This family portrait was shot using automatic TTL flash. Exposure was set so the ambient light would provide illumination to retain some of the background detail in the church. Photo: Scott Augustine/Mayfair Two Studio

should be heeded unless you specifically decide to make the image lighter or darker than usual.

Flash Exposure Compensation

As mentioned earlier, the Flash Exposure Compensation feature of the Elan/100 can only be used with the built-in flash. Even if a compensation value is set and displayed on the LCD panel, it will have no effect on an external flash unit. Therefore, it is fortunate that the 540EZ has Exposure Compensation of its own, which is even more powerful than that of the camera.

To use Flash Exposure Compensation, the 540EZ must be set to the A-TTL or TTL mode. (The Manual flash mode offers a different method of controlling the unit's output.) Press the Select/Set below the 540EZ's LCD panel, and two symbols appear and start blink-

ing. One is the flash-compensation icon, consisting of a lightning bolt next to plus and minus symbols, within a black box. The numeral 0 also blinks to show that no flash compensation has been set. While these symbols are blinking, you push either the Plus or the Minus button to choose the desired amount of over- or under-exposure. The compensation range is plus/minus three EV, in 1/3-EV increments. (By comparison, the Flash Compensation system of the Elan/100 offers a plus/minus two EV range, in 1/2-EV steps.)

Once you have chosen the degree of compensation, either wait for eight seconds or else press the Select/Set button. Either way, you lock in the setting, and the blinking ceases. The flash-compensation icon remains, however, along with a plus or minus sign and the appropriate numeral and/or fraction. Even if you are particularly impatient and fire the flash before the blinking stops, the flash output will be increased or decreased by the chosen amount. The compensation setting remains until you change it, even if the 540EZ is turned off and on repeatedly.

As the name implies, flash compensation affects the amount of light emitted by the flash. If you follow my advice and only use A-TTL flash for full-scene illumination, the compensation therefore controls the brightness of the entire picture. Remember, A-TTL is only available in the Program AE mode and in the Image Zone. In the Elan/100's other modes, flash automation is done with the TTL system, which (once again) is best suited to illuminating foreground subjects. Used in this way, Flash Compensation affects the brightness of the main subject, but has little or no effect on the background. If you wish to change the background as well, use the ambient-light Exposure Compensation function of the Elan/100.

In fact, both Exposure Compensation and Flash Exposure Compensation can be employed at the same time. For example, you might want to brighten the background and tone down the flash to create seamless outdoor fill-flash effects. In that case, Exposure Compensation would be set in the plus direction, and Flash Exposure Compensation on the minus side.

There may also be occasions when you want to brighten or darken both the flash-lighted foreground and the ambient-lighted background by an equal amount. To do so, it is easier to change the film ISO setting than to make separate adjustments to both Exposure Compensation systems. In some cases, this may be the only way to achieve an equal degree of compensation because

Exposure Compensation varies in 1/2-EV increments while Flash Exposure Compensation (on the 540EZ) is chosen in 1/3-EV steps. They correspond only in full-step increments, not in fractions or mixed numbers.

Manual Flash Mode

This section deals with the Manual mode of the 540EZ, which operates with the Aperture-Priority AE or Manual exposure modes of the Elan/100. If any other Creative Zone mode is set on the Command Dial, the minimum aperture of the lens blinks on the camera's LCD panels. The flash will still fire, but the exposure will probably be wrong. If you move the Command Dial to the Image Zone, the 540EZ automatically switches to the A-TTL mode and operates normally. (Just one more precaution to keep those Image Zone kids out of trouble.)

To select the Manual Flash mode, just press the Mode button until an M appears on the LCD along with the strange fraction 1/1. This signifies that the 540EZ will fire at full power. Simultaneously, a single dash appears on the flash LCD, at the distance setting that will be properly exposed by the chosen f/stop. Change the aperture, or the flash output level, and this distance marker will move.

Eight levels of flash output are available: 1/1 (full); 1/2; 1/4; 1/8; 1/16; 1/32; 1/64; and 1/128. You choose one by pushing the Select/Set button, which makes the numeral (such as 1/1) blink on the 540EZ's LCD. Then, each push of the Minus button changes the fraction to the next lower value. (If the flash is already at a fractional output value, pressing the Plus button increases it.) When you reach the desired value, press Select/Set again to lock it in. If you don't push Select/Set for eight seconds, the output will be locked in anyway and the blinking will stop. Even if you take a picture while the display is blinking, the chosen output value will be used.

In the Aperture-Priority mode, you choose the f/stop, and the Elan/100 automatically sets the 1/125 second flash-sync speed. There is no way to select a slower speed, and of course a faster one is out of the question. Therefore, exposure is only likely to be correct at the distance shown on the flash LCD scale. This is not how Aperture-Priority usually works, and I can see no advantage in choosing it for Manual Flash photography.

The Manual Exposure mode of the Elan/100 offers far more flexibility. You can choose any shutter speed from 30 seconds to 1/125,

and any aperture you wish. That way, you can use the camera's Exposure Confirmation system to set the correct values for the ambient-lighted portions of the scene. The flash output is then adjusted for proper exposure of the foreground.

You might want to try this method when photographing a cocktail party. With ISO 200 film the overall exposure may be about 1/8 second at f/2.8. Set the flash to its smallest output level, 1/128 power, and you have a perfect "wink" light for subjects at about a seven-foot distance (as shown on the LCD). Even better, kick the shutter speed up to 1/15 second so the background will be slightly toned down, without fading to black.

Another use for low-power, manual flash is in still-life photography. You can remove the flash from the tripod-mounted camera and trigger several bursts to highlight different areas of the scene. This may be accomplished during a long exposure, or with the Elan/100's Multiple Exposure function.

At low-power Manual settings, the 540EZ can keep up the Elan/100's motor drive. Just be sure the subject is at the right distance to be properly exposed by the output level and aperture in use. And be careful not to overheat the flash head! Canon warns of possible damage if these limits are exceeded: 15 continuous flashes at full or 1/2 power; 20 at 1/4 or 1/8; 40 at 1/16 or 1/32. At the lowest power levels, heat build-up should not be a problem.

Stroboscopic Flash

In common parlance, electronic flash is often called "strobe" light. More properly, however, stroboscopic flash refers to a light that fires repeatedly during an exposure. It is often used to make multiple images of a moving subject, such as a dancer or even a splash of milk. To set the 540EZ for Multiple Flash output, just press the Mode button until MULTI appears on the LCD. Also visible will be three dashes and the motto 1Hz.

Three parameters define the operation of stroboscopic flash: the firing frequency, the number of bursts, and the power output of the flash unit. With the 540EZ in the Multi mode, each push on the Select/Set accesses one of these factors, whose value can then be altered with the Plus and Minus buttons. Each value is displayed on the LCD panel and blinks while you are setting it. In this way, you choose a firing-frequency setting from one to 100 Hz (which stands for Hertz, or in this case for flashes-per-second).

The number of bursts, which replaces the dashes on the LCD, can vary from one up to 100, although the maximum depends on the firing frequency and output level. If you don't set a number of flashes, the dashes remain on the display. This means that the 540EZ will emit as many bursts as possible, given the constraints of time and power. The output level for Multi shooting can be as high as 1/4 power, or as low as 1/128.

Multi flash should be used with the Elan/100 in the Manual exposure mode, or in the Bulb (time exposure) mode if you prefer. One important consideration is that the shutter speed must be long enough to allow the complete strobe series to occur. A simple example: 20 bursts at a 20 Hz interval take about one second. So the shutter speed needs to be a least that long, and preferably a little longer to provide a margin of safety.

The scale on the 540EZ will display the flash-to-subject distance for proper exposure, considering all the parameters that you have set. As in the Manual flash mode discussed above, background exposure is guided by the Elan/100's Exposure Confirmation display.

A series of charts in the 540EZ Instruction Book display the maximum number of bursts at each power level, and for each frequency. This is a useful reference, but it's not absolutely necessary for Multi flash work. The electronic memory of the 540EZ is pre-programmed with this information, and the unit simply won't let you set any combinations that are beyond its capacity. Although each series is safe, many of them in quick succession could cause overheating, so a little caution is in order. An external power pack may also be a good idea because Multi flash requires a great deal of energy and can quickly drain your batteries.

Second Curtain Sync

The technique of second-curtain flash synchronization was discussed in a previous chapter. As a quick review, it allows the flash to fire at the end of a long exposure rather than at the beginning. With a moving subject, this creates a sharp main image and a blurred trail behind it.

Second curtain sync is set with the Elan/100's Custom Function control. It operates with the 540EZ just as it does with the built-in flash unit.

Close-Up Flash

When shooting subjects between 1.7 and 6.6 feet (0.5 to two meters), it's a good idea to tilt the flash head down to its seven-degree Close-Up position. This ensures that the entire image area is properly exposed. A close-up logo, in the form of a tipped-down flash, will appear on the 540EZ's LCD.

Any mode of the Elan/100 can be used with close-up flash, but more information is shown on the flash LCD when you set the camera to Aperture-Priority, Shutter-Priority, or Manual exposure. In these modes, the flash distance scale displays the 1.7-6.6 foot range, and the rest of the scale blinks to indicate that greater distances should not be used. If the chosen f/stop is too wide for close-up shooting, the entire scale blinks.

Except for common sense, there is nothing to prevent you from taking a flash close-up at f/2.8. And don't be fooled by the Exposure Confirmation light; it glows equally bright whether there is enough illumination or far too much. You may be better off using use Program AE with close-up flash to avoid having to worry about an inappropriate aperture setting. The A-TTL system will set 1/60 or 1/125 second and a very small aperture, which is probably just what you want. Although there is no distance display in this mode, it is not a major loss.

Bounce Flash

Direct flash often creates a harsh look, with dark shadows and brilliant highlights. For a softer effect, you can adjust the 540EZ's flash head to "bounce" light off the ceiling or wall. This surface diffuses the flash output and becomes, in effect, a giant light source. The result is a softer, more natural look.

Separate Bounce Latch controls allow the flash head to be moved either up/down or left/right. The two movements can also be combined, which is useful when you want to bounce light diagonally, perhaps over your shoulder to the corner of the room. Click stops are provided in all directions to make bounce settings easily repeatable. In the up direction, these clicks are at zero degrees (straight ahead), 60 degrees, 75 degrees, and 90 degrees (straight up). (This same control also permits the flash head to move seven degrees down, for close-up shooting.)

With the camera held horizontally, the up direction sends bounce light to the ceiling. The 90-degree position is best for

nearby subjects, while the smaller angles "throw" the light more efficiently for distant subjects in large rooms. In any position, a pictogram on the LCD panel shows that the 540EZ is in bounce mode. By the way, the Up direction can also be used for vertical shots to bounce light off a nearby wall. This way, you get diffused light along with some sense of direction.

Left/right movement is generally employed for ceiling bounce with a vertically oriented camera. If you hold the Elan/100 "properly," with the shutter button to the bottom, the ceiling is to the left. In that direction, click stops are provided at zero (straight ahead), 60, 75, 90, 120, 150, and 180 degrees (straight back). For independent souls, there are also clicks to the right, at zero, 60, 75, and 90 degrees. Naturally, the left/right rotation can also be used with a horizontal camera, to bounce light off the walls.

A small drawback of bounce flash is that it sometimes looks a little too soft. Particularly with portraits, you may miss the sparkle in your subject's eyes. Here's how to get it back: With the flash head in the 90-degree bounce position, pull the Wide Panel partway out, but don't turn it over the reflector. This way, a small portion of the flash output is directed forward by the panel, creating a "catchlight" in the subject's eyes. The catchlight setup is ideal for subjects within about five feet of the flash, and can be used either for ceiling-bounce with horizontally-oriented images or wall-bounce with vertical images.

For any subject, bounce flash works best in rooms that offer unadorned white or light-colored surfaces. If you bounce off a green ceiling, for example, your subjects may acquire a rather sickly pallor. Also beware of prominent patterns, which may create strange shadow effects. Most of all, avoid dark, matte surfaces. These absorb too much of the light and reflect too little onto the subject. Another bete noire is the 12-foot ceiling, often found in reception halls. When you bounce, the light has to travel up to the ceiling, be diffused, and then be reflected to the subject. Considering the total distance, a low ceiling can save a whole lot of light.

When a bounce shot has been properly exposed, the Exposure Check lamp on the back of the 540EZ will glow for about two seconds. If that's not happening, try setting the Elan/100 in the Manual exposure mode, with the shutter speed as low as you can hold, and the lens wide open. Alternately, you may want to use faster

film. And for extensive bounce shooting, which is bound to wear out your batteries, an external power pack is a great addition.

Multiple-Flash Setups
Professional photographers often use more than one flash unit to illuminate their studio setups. That way, the proper amount of illumination can be directed to the main subject, to the background, and to fill in deep shadows. Canon offers a group of accessories that allow EOS SLRs, such as the Elan/100, to be used with up to four dedicated flash units. All of the E, EG, and EZ Speedlite models, as well as the Macro Ring Light, can be joined for multiple-flash setups.

A treatise on multiple-flash work is beyond the scope of this book. Nonetheless, I can provide a taste of how the flash-accessory system works. To start, you need a TTL Hot Shoe Adapter 3, which fits into the Elan/100's hot shoe. There is another hot shoe on top of the Adapter, to hold a 540EZ (or other Canon flash unit), and a socket for a dedicated Connecting Cord. For a two-flash setup, this cord is attached to an Off-Camera Shoe Adapter, holding the second flash unit. Each Connecting Cord 300 is 10 feet (three meters) in length; up to three can be attached end-to-end, for a total camera-flash-distance of 30 feet (nine meters). For shorter runs, the Connecting Cord 60 is two feet (0.6m) long.

If your lighting set up requires three or four flash units, use the TTL Distributor. This accessory has sockets to accept up to four Connecting Cords, one from the Hot Shoe Adapter, and the others leading to Off-Camera Shoe Adapters.

The TTL mode of the 540EZ provides accurate, fully automatic exposure control for multi-flash arrangements. (A-TTL only operates in single-flash set ups.) The valuable Exposure Confirmation lamp continues to work as well. You also have the choice of setting all flash units for manual firing at any output level. The SE function can switch off all of the units after a 90-second pause, which is a great convenience in a large studio. And for truly exotic results, the Multi mode is available for multiple-flash stroboscopic photography.

Perhaps you would like to spice up your lighting but are not yet ready to plunge into multiple flash. The Off-Camera Shoe Cord 2 may do the trick. This accessory consists of a small box that fits into the hot shoe of the Elan/100, a separate shoe to hold the

This photograph was shot with a 540 EZ flash mounted on a Stroboframe flash bracket. Notice how the shadows fall behind and below the subject for a more natural lighting effect. Photo: Scott Augustine/Leichtner Studios

540EZ, and a coiled cord that connects the two units. The Shoe Cord allows you to move the flash off camera by up to two feet (0.6 m) for improved control of the lighting angle. All flash functions of the Elan/100 and of the 540EZ are maintained with this simple, yet flexible setup.

Lenses and Accessories

The most important capability of a fine SLR, such as the Elan/100, is not apparent when you pick up the camera. Yes, it's wonderful to have advanced features such as multiple metering modes, quick autofocus, and a bright viewfinder. As you know by now, the Elan/100 includes all of these, and then some. But the best thing about a fine SLR is that it is the heart of a complete system of lenses and accessories. To draw an unfair comparison: Start with a point-and-shoot camera, and that's where you will finish. Begin with an EOS Elan/100 and your camera system can expand as your abilities do. So let's explore the EOS system, starting with the remarkable range of Canon EF lenses.

Ultra Wide-Angle Lenses

As a somewhat arbitrary convention, any lens with an angle of view of 90 degrees or greater (measured across the diagonal of the film frame) is considered an ultra wide-angle. These exotic and expensive lenses "see" far more than the human eye can sharply perceive at any given moment. Perhaps that's why ultra-wides can be the most difficult lenses for the beginner to master. If used carelessly, an ultra wide-angle lens can create unpleasantly egg-shaped images of people's heads and combine totally unrelated subjects in the same picture. When used for landscapes, they can easily include extremes of light and shadow that are beyond the latitude of any film.

Once you get the knack, however, using an ultra-wide is nothing short of visual liberation. You can encompass almost any

The converging vertical lines and exaggerated perspective often seen in architectural photographs are caused by pointing the camera up at the subject. Adding people to the image helps maintain a sense of scale. Photo: Bob Shell

A 15mm ultra wide-angle lens was used to create this unusual wedding portrait. Photo: Scott Augustine/Mayfair Two Studio

interior without having to back up onto the fire-escape. Mighty mountains and soaring skyscrapers are brought into view, minus the annoying "falling back" effects created by pronounced camera tilt. Best of all, foreground and background objects can be visually related, with every inch rendered sharply in focus.

The Canon EF (electronic focus) lens system offers three ultra wide-angle lenses with fixed focal lengths and a pair of zooms that extend into the ultra-wide range. By far the widest angle of view, an awesome 180 degrees, is offered by the Fish-Eye EF 15mm f/2.8 lens. This is a full-frame fish-eye, so although straight lines are curved, the whole image does not look like a reflection in a Christmas-tree ornament. Unlike some of its peers, focusing is automatic and its speed is more than sufficient.

Although similar to the fish-eye in focal length, the EF 14mm f/2.8L USM is a rectilinear wide-angle, which means that straight lines remain straight. The "L" designation signifies Canon's high-end "Luxury" lens series, in this case incorporating a large-aper-

ture aspherical lens element for maximum sharpness and minimum distortion over the 114-degree field of view. Like many EF lenses, this one incorporates a USM (ultrasonic motor) for particularly quick, quiet focusing. Filters are built-in.

If a little less angle will do (as it usually will), consider the EF 20mm f/2.8 USM lens. Significantly smaller and lighter than the 14mm, it includes a similar focusing motor, a floating lens element (for optimum correction throughout the focusing range), and a non-rotating front element (for ease of use with polarizers). The 94-degree angle of view of view is a bit easier to handle than 114 degrees, yet still wide enough for spectacular results.

In fact, if 20mm is your thing, the EF system offers two more choices. Among the few zooms that reach into this ultra-wide territory are Canon's non-identical twins: the EF 20-35mm f/2.8L and EF 20-35mm f/3.5-4.5 USM. Each spans the wide-angle range from ultra (94 degrees) to moderate (63 degrees), effectively providing

The Canon EF 15mm f/2.8, a fish-eye with a 180° angle of view.

all the wide-angle capability that most photographers will ever need. Like many siblings, these two differ in important ways. Available-light photographers will appreciate the fixed, fast f/2.8 maximum aperture of the "L" version, which also features an aspherical element and a non-rotating front end. Those on a budget may

Canon's EF 14mm f/2.8, a very sharp, high-speed, ultra wide-angle lens.

opt for the compact, relatively inexpensive model. Although it has a slower, variable maximum aperture, this newer design offers quiet USM focusing.

Wide-Angle Lenses

As it does in virtually every range, Canon EF system offers a healthy selection of wide-angle lenses in both fixed focal length and zoom types. Years ago, there was no real choice; the discerning photographer would choose a fixed 35mm lens for everyday candid shooting, a 28mm for interiors, and perhaps a 24mm for landscapes. These lenses were small, light, fast, and sharp; everything that zooms were not.

Although today's fixed focal length lenses are better than ever, zooms have progressed at an even faster rate. Thanks to high-speed computer-design programs, fancy glass, aspheric elements, and multi-layer coating, modern zooms are good enough to satisfy most photographers most of the time. Zooms still tend to be relatively slow, but that's not much of issue for those who shoot fast film or work extensively with flash. Even the variable maximum-

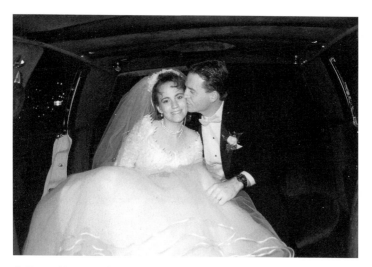

A Canon EF 20mm f/2.8 USM wide angle lens allowed the photographer to capture the bride and groom in the limited space inside their limo. Photo: Scott Augustine/Leichtner Studios

aperture design, which used to make light metering difficult, is now handled automatically by TTL (through-the-lens) meters.

For EOS photographers who prefer traditional optics, three fixed focal length wide-angles are available: EF 24mm f/2.8, EF 28mm f/2.8, and EF 35mm f/2. Angles of view, respectively, are 84, 75, and 63 degrees; optical designs are conventional, except for an aspherical element in the 28mm. Before jumping to the zooms, however, consider that these tried-and-true optics have some real advantages.

Each of these lenses weighs less than ten ounces, measures under two inches in length, and focuses to one foot or closer. Maximum aperture is at least as fast as any zoom, and faster in the case of the 35mm. Do they still outperform the zooms where it counts, on the image itself? There is no simple answer, but here's a thought: the 28mm lens has five elements, about half as many as a comparable zoom. All else being equal, fewer elements means less flare, an important advantage when shooting sun-drenched landscapes or hot-lighted interiors.

The EF 24mm f/2.8 and EF 28mm f/2.8, two wide angle lenses which are ideal for landscape photography, photojournalism, architecture and interior photography.

Wide-Angle Zooms

The great advantage of zoom lenses is convenience. It's a lot easier to carry one or two zooms than a bag loaded with fixed lenses, and you are more likely to have the right focal length available when an unanticipated subject suddenly appears. When shooting inaccessible subjects, or from a fixed position, zooms allow far more precise composition than would otherwise be possible. This is particularly important with color slides, which are usually shown uncropped.

As a testament to the popularity of wide-angle zooms, the Canon EF system offers a remarkable choice of nine zoom lenses with wide-angle capabilities (plus the two ultra-wide 20-35mm zooms). Three start at 28mm, and range to 70, 80, and 105mm, respectively. The other six begin at 35mm, and extend to 80, 105, 135, or an astonishing 350mm. If any type of lens can be said to do everything, the wide-angle zoom has got to be the one.

This versatility is what draws so many buyers of the Elan/100 to start out with the compact EF 28-80mm f/3.5-5.6 II USM zoom rather than a standard 50mm lens. The focal length range, from true wide-angle through normal to portrait telephoto, makes this an ideal lens for all-around picture taking; angles of view range

A wide-angle lens and a small aperture are the best combination for expansive scenic shots with maximum depth of field. Photo: Bob Shell

from 75 to 30 degrees. The lens is lightweight enough to balance perfectly on the Elan/100 body, and it offers a surprising dose of high-tech for a reasonably priced optic: ultrasonic motor, aspherical element, macro-focusing capability. The "II" designation means this is the second-generation EF lens of this focal length and aperture range.

If speed is more important than reach, try the ED 28-70mm f/2.8L USM. This "luxury" lens is far bigger in price, size, and weight than its economical counterpart, but the payoff is a consistently fast maximum aperture and absolutely superb optical performance. Or, if a little more telephoto power is required, the logical choice is the EF 28-105mm f/3.5-4.5 USM. Angle of view at the long end is a relatively narrow 23 degrees, powerful enough for tight head-and-shoulders portraiture from a comfortable shooting distance. Zoom range is almost 4x, enough for anything a weekend will bring your way.

Like animals on the Ark, some EF zooms come in pairs. For example, there is the EF 35-80mm f/4-5.6 USM and the newly introduced EF 35-80mm f/4-5.6 III. Each is a compact, lightweight

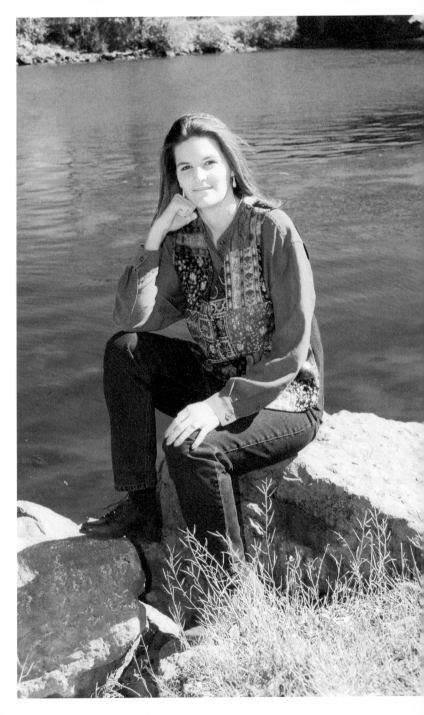

zoom with a range from medium wide-angle to short telephoto, and macro-focusing capability. The major difference is in the focusing motor: advanced USM in the more expensive version, "standard" micromotor in the price-leader model. Either one is a fine "normal" lens, but I think the wider range of the 28-80mm model makes it an even better all-in-one optic.

Another zoom duo offers a little more reach: the EF 35-105mm f/4.5-5.6 USM and the EF 35-105mm f/4.5-5.6. Each has an aspherical element and macro focusing. Again, the major difference is in the focusing motor—ultrasonic vs. micromotor. USM is faster, quieter, and a bit more expensive. For my money I would go with the 28-105mm rather than either of these. It's a little longer and heavier, but the minimum focusing distance is even closer, the maximum aperture is bigger, and the 28mm focal length offers 12 degrees more coverage. That makes a big difference on the open plains or in a cramped room. The built-in flash of the Elan/100 covers the 28mm field of view, so why not take advantage?

Still more telephoto power is available in the EF 35-135mm f/4-5.6 USM. Angle of view narrows to 18 degrees, enough to pick out architectural details on nearby buildings. In addition to the desirable USM, this lens features an aspherical element, macro focusing, and a non-rotating front element.

Of course, the photographer who wants everything has to reach for the moon, or more specifically the EF 35-350mm f/3.5-5.6L USM.

No, it's not a typo. The lens really exists; I've tried it and it works. About seven inches long and weighing in at three pounds, this optical marvel has a 10x focal length range—more commonly found on a camcorder than on a 35mm SLR. One mighty zoom takes you from 63 degree wide-angle to 3 1/2 degree long-telephoto, replacing (by my estimation) eight fixed lenses. I'm not sure what purpose this lens serves, but just knowing that the Canon optical engineers can create such a thing gives me added confidence in their more mundane efforts. Come to think of it, that could be just why the lens was created.

⟁ **Canon's popular EF 35-80mm f/4-5.6 USM was used with the zoom set to 80mm for this outdoor portrait. Photo: Scott Augustine/Leichtner Studios**

Canon EF 35-70mm f/3.5-4.5 A

Canon EF 35-70mm f/3.5-4.5

Canon EF 25-80mm f/4.0-5.6 Power Zoom

Canon EF 35-80mm f/4.0-5.6 II

Canon EF 35-80mm f/4.5-5.6 USM

Normal Lenses

In photography, as in so many areas of life, "normal" is defined by what most people like. By that criterion, the traditional 50mm lens has not been normal for quite a while. As mentioned earlier, the wide-angle to short-telephoto zoom is the lens usually sold with modern SLRs. It offers far more flexibility than a fixed-focal length lens, albeit with less speed and at a higher price. So why consider a 50mm at all?

Each of the EF-system lenses has its own raison d'être. The most conventional of these, the EF 50mm f/1.8II, is also the most compact and least expensive lens in the entire EF system. It weighs less than five ounces! No fancy optical or electronic technology, perhaps, but this little lens gives tack-sharp images over an eminently usable 46-degree angle of view. The f/1.8 speed is nothing special for a 50mm, yet a full two stops faster than the typical zoom. That extends the available-light capability of your favorite film and the distance range of any flash. Not bad for a handful of dollars.

Moving up the scale, we come to the EF 50mm f/1.4 USM—a little larger, 2/3-stop faster, and equipped with an ultrasonic focusing motor. Like its small sibling, this speedy lens focuses continuously to 1.5 feet, which is fine for medium-close work. (But don't use a 50mm for full-head portraits, unless you prefer Cyrano-style noses.) And f/1.4 is fast enough for almost any lighting condition.

If that still isn't enough, the EF 50mm f/1.0L is the fastest standard lens ever made for an SLR. It is a full stop faster than the f/1.4, almost two stops speedier than the f/1.8, and about four stops quicker than a typical zoom. Aspherical elements and a floating-element design maximize sharpness, even wide open, which is how this pricey lens will be used. At that aperture there is precious little depth of field, so the background will be completely soft and unobtrusive. Used with fast film, this lens lets you shoot indoor sports at shutter speeds high enough to freeze action, sans flash. The USM focusing motor, combined with the Elan/100's quick AF system, ensures that the point of focus will be where you want it to be.

For a different approach to the 50mm lens, consider the EF 50mm f/2.5 Compact Macro. Here the focus is not on speed but rather on optimum performance in the extreme close-up range.

Unlike a conventional lens fitted with a bellows or close-up attachment, the 50mm f/2.5 focuses continuously and automatically from infinity to its close limit of 0.5x (1/2 life-size image on film). Attach the Life Size Converter EF, and the lens focuses automatically over the range from 1/4 to full life size. Without the converter, sharpness is excellent at normal distances as well. This lens is a fine choice for nature photographers, stamp collectors, or anyone who wants a close-focusing 50mm.

Moderate Telephoto Lenses

Moderate-power or "short" telephoto lenses bridge the gap between the "normal" range and true space-spanners. They tend to be compact enough for comfortable hand holding and fast enough for working with available light. With angles of view from 28 1/2 degrees (for an 85mm lens) to 12 degrees (for a 200mm), they perform a most valuable function: in-camera cropping of extraneous details. Switch from a 50mm to a 135mm, for example, and you're forced to decide what is the real subject of each picture.

The Canon EF system includes some of the fastest telephoto lenses on the market, which share much technology with the remarkable 50mm f/1.0L. In fact, the second fastest lens in the system is the EF 85mm f/1.2L USM. As it happens, these two lenses are very similar in physical appearance and they both have aspherical elements, an advanced optical system that "floats" elements as it focuses, and of course the ultrasonic focusing motor. The 85mm focal length is better suited to head-and-shoulders portraiture, and its wide aperture can easily reduce the background to a beautiful blur. Other logical uses are indoor sports and outdoor scenics after sunset.

Naturally, the 85mm f/1.2 is quite expensive, and not everyone absolutely needs that last drop of speed. If you can live with about a stop less, the EF 85mm f/1.8 USM offers several advantages. It is smaller, lighter, and considerably less costly. The ultrasonic motor and floating-element design are just as effective, the minimum focus is a little closer, and the filter size is only 58mm (versus 72mm). Although this lens was designed specifically for the EF system, Canon has been making fine 85mm f/1.8 lenses since the days when bell bottoms were first considered hip.

TOP: Two 85mm lens choices, the EF 85mm f/ 1.8 USM (left) and the faster EF 85mm f/ 1.2 L USM (right).

BOTTOM: The EF 100mm f/2.0 USM (left) is an optimal high-speed portrait lens while the EF 200mm f/2.8 (below) is a fast fixed-focal length telephoto.

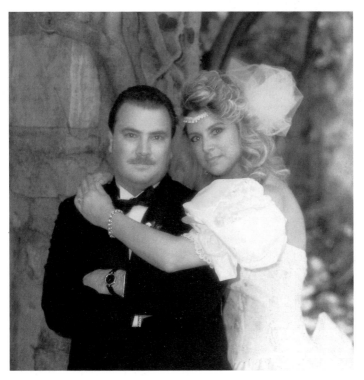

The Canon EF 100mm f/2 USM is a lens typically used for wedding and portrait photography. Moderate telephoto lenses are favored because they allow to photographer to maintain a comfortable camera to subject distance. They also appear to compress space to de-emphasize prominent facial features. Photo: Scott Augustine/Mayfair Two Studio

A logical alternative to the 85mm f/1.8 is the EF 100mm f/2 USM, which trades off a little bit of speed for a touch more magnification. With an angle of view of 24 degrees, this lens is a fine choice for dramatically tight, head-only portraits. It's still fast enough for indoor sports, and portable enough (at 16 ounces) to haul around all day. Technical details are similar to the 85mm f/1.8, including a non-rotating 58mm filter mount that can be used with conventional polarizing filters.

A different approach to the same focal length is taken by the EF 100mm f/2.8 Macro lens. This unusual telephoto lens focuses continuously from infinity to one foot, providing full life-size images on film without the use of accessories. And the longer focal length, as compared with the typical 50mm macro lens, provides more working room between the lens and the subject. This greater distance makes it easier to set up lighting around small subjects, and often provides a more pleasing perspective. Optical performance at all distances is enhanced by a floating element, so portraits and scenics will be as sharp as macro subjects. A non-rotating front element makes it easy to use filters.

**Canon EF 135mm f/2.8
Softfocus.**

The next member of this group is the EF 135mm f/2.8 Soft Focus, a lens with a kind of split personality. On the one hand, it's a fast telephoto with 2.7x magnification (compared with 50mm), and an 18 degree angle of view well suited for landscapes or candid portraits on the street. The other identity is as a soft-focus portrait lens, with the degree of softness adjusted on a continuously variable soft-focus ring. Aperture also effects the soft-focus look, which is most pronounced with the lens wide open. Unlike many such designs, the 135mm f/2.8 is tack sharp in its normal mode; the soft-focus feature is simply a welcome bonus.

To my mind, 200mm is about the longest focal length that can be considered a moderate telephoto. With a 12 degree angle of view, it is powerful enough for some wildlife photography and outdoor sports, yet still permits easy carrying and hand-held shooting. The EF system offers two speedy choices in this focal length, the EF 200mm f/1.8L USM and the EF 200mm f/2.8L USM. As usual, the tradeoff is between maximum speed and maximum mobility. Although neither lens is inexpensive, the f/2.8 is by far the more affordable of the two. Both models have every technical tweak imaginable, including ultra-low dispersion glass, but the f/2.8 has the advantage of focusing closer (five feet versus eight feet), and weighing about 1/4 as much. It is still faster than most zooms and gives a nice, bright viewfinder image. There are situations, however, when only pure horsepower will do. For shooting a dark-colored animal in the shadows or a football player on a miserable, rainy day, that f/1.8 speed can be a life saver.

Telephoto Zooms

The only type of lens as popular as the wide-angle zoom is the telephoto zoom. These lenses offer the same advantages of convenience and precise cropping, although there is a conceptual difference. The wide-angle zoom spans different optical genres (usually wide-normal-short telephoto), while the telephoto zoom offers a range of magnification within a single realm. (There are a few normal-to-telephoto lenses on the market, but nobody seems to buy them.)

As a testament to the popularity of telephoto zooms, the EF line includes no less than six of them. The telephoto zooms start at 70,

75, 80, or 100mm, and extend to 200, 210, or 300mm. The fastest of the group has a constant maximum aperture of f/2.8 and the slowest is f/5.6 throughout. The others have variable maximum apertures. There are technical differences as well, and significant variations in magnification range. Yet all of these lenses can be considered "do everything" telephotos, useful for travel, landscape, portraiture, and some sports or nature subjects. Virtually all are hand-holdable, and most are reasonably affordable. If you intend to buy only one telephoto lens, definitely check out this category first.

As I mentioned earlier, Canon tends to offer its zoom lenses in pairs. Within each duo, both lenses have an identical (or virtually identical) focal length range but differ in maximum aperture and degree of technical sophistication. So it is not surprising that the six telephoto zoom lenses include two pairs.

The first set consists of the brand new EF 70-200mm f/2.8L USM and the 70-210mm f/3.5-4.5 USM. The fast 70-200mm is actually an update of the previous 80-200mm f/2.8L, now with a slightly wider zoom range and an ultrasonic motor. As a member of the "L" series, the 70-200mm is rather expensive, but if its optical performance simply matches that of the earlier lens, critical user will be quite happy. And focusing is sure to be faster, thanks to the new motor. The same ultrasonic focusing system is available in the 70-210mm zoom, along with internal focusing and a non-rotating filter mount. The slower lens is much lighter and less expensive as well.

Perhaps you like a zoom with a little more reach to photograph the high school football game or some reticent deer. In that case, a good choice is the 75-300mm f/4-5.6 USM. This 16-ounce lens offers angles of view from 32 to eight degrees, and macro focusing. Filter size is a reasonable 58mm. A second-generation version of the 75-300mm zoom, bearing the "II" designation, is on the way but no details were available at press time.

The EF 80-200mm f/4.5-5.6 USM is by far the most compact Canon tele zoom, measuring about three inches long and weighing only nine ounces. That makes it ideal for travel and for arduous backpacking. Although this zoom is rather slow, it's a lot easier to pack some high-speed film than to schlep a big hunk of glass and metal. The 80-200mm covers a range from 30 to 12 degrees and even includes macro focusing, so you can capture the occasional wildflower by the trail.

The fast EF 80-200mm f/2.8 L is an excellent lens for low-light photography or for isolating the subject by using a wide aperture opening.

Finally, we come to a rather exotic set, the EF 100-300mm f/5.6L and the EF 100-300mm f/4.5-5.6 USM. Contrary to usual Canon practice, the techno goodies are spread through both lenses. The f/5.6 lens, which you might expect to be a stripped down model, is a legitimate member of the "L" series. Its optical system boasts an advanced fluorite lens element and ultra-low dispersion glass for image quality that rivals a fine fixed-focal length lens. If very fast focusing is more important, however, the f/4.5-5.6 version has a USM motor, plus a non-rotating front element for optimum use of polarizing or split-neutral-density filters. Both lenses offer macro focusing as well. I'm not sure why the "L" version does not incorporate a USM, but I'd bet the next version will do so.

Long Telephoto Lenses

We are now in the realm of serious glass, suitable for stadium sports or stalking the wild rhinoceros. Some people also spy on their neighbors, although the less said about that the better. This range, from 300 to 1200mm, requires a tripod (or perhaps a monopod if you're adept), high shutter speeds, and fast film.

Magnification is 6x to 24x, compared with a 50mm lens, and angle of view ranges from about eight to two degrees. We're talking tele!

The six lenses in this group are: EF 300mm f/2.8L USM, EF 300mm f/4L USM, EF 400mm f/2.8L USM, EF 500mm f/4.5L USM, EF 600mm f/4L USM, and 1200mm f/5.6L USM. As you see, all six are part of the "L" line, and all feature USM autofocus. They have much else in common: ultra-low dispersion glass elements, internal focusing, non-rotating front elements, and a focusing-range selector. The latter is a device that lets you divide the focusing range into sections, such as "closer than 50 feet" and "50 feet to infinity." By restricting the range, you let the AF system find the actual point of focus that much faster.

One might consider the 300mm f/2.8 and f/4 lenses to be the "babies" of this group, for they weigh in at a mere 6.3 and 2.9 pounds, respectively. In fact, the slower lens is hand-holdable if you are strong and steady enough. Both lenses have smooth manual focusing, which is a real advantage with seriously off-center or low-contrast subjects. Their 8 1/4 degree angle is fine for tennis or hockey, but probably a little short for football. (The Canon Extender EF 1.4X or Extender EF 2X can easily remedy the shortfall.) And the f/2.8 version, in particular, can throw the background pleasingly out of focus.

Canon introduced a manual-focusing 400mm f/2.8 lens back in 1980, and professional sports photographers immediately adopted it as their own. The current EF version is optically identical to that original lens, with two ultra-low dispersion elements to minimize color aberrations, a particular concern with long, fast lenses. With the addition of USM autofocus, the EF lens is even better suited to fast action than was its famous predecessor. Attach an EF extender and you get a 560mm f/4 or an 800mm f/5.6, still with AF and autoexposure operation.

Our history lesson continues with the 500mm f/4.5, a direct descendent of a manual-focusing lens introduced during the Carter administration. This updated oldie is a goody, with rear-focusing design and one each fluorite and ultra-low dispersion glass element. Despite its power and speed, the 500mm f/4.5 is surprisingly lightweight (6.6 pounds) and small (15 inches in length). It may be a bit much to handhold, but at least you won't get a hernia hauling the lens to the ballpark or into the woods.

A more recent entry is the 600mm f/4, developed specifically

Canon EF 200mm f/1.8 L USM

Canon EF 300mm f/2.8 L USM

Canon EF 400mm f/2.8 L USM

Canon's two EF Extenders: the 1.4x on the left and the more powerful 2x on the right.

as an autofocus lens for the 1988 Calgary Winter Olympics. Endowed with one fluorite element and two UD glass elements, this stovepipe yields images with remarkable clarity and contrast. The addition of an Extender 1.4X converts it into an autofocus 840mm f/5.6; with the Extender 2X you get a manual focusing 1200mm f/8.

If still more optical power is needed, try the local observatory or the slightly more compact 1200mm f/5.6L. This special-order Canon cannon measures 33 inches long and weighs in at a svelte 36 pounds. Despite all that bulk, a USM provides fast autofocusing, for subjects at least 46 feet away. The 24x magnification is actually too powerful for most sports shooting, but it would be a natural for close-ups of a space shuttle launch. Or you could check whether the man in the moon has a clean shave.

The Canon Tilt-Shift lens family, consisting of 24mm, 45mm and 90mm lenses. All allow the lens to be shifted in its barrel, and tilted as well, a feature offered by no other 35mm camera system.

Teleconverters

Teleconverters, also called extenders and sometimes doublers, used to have a terrible reputation. This was because the early designs, often with only a single optical element, degraded the image to an unacceptable level in the process of increasing the magnification of the lens. Nowadays, many makers produce very high-class teleconverters, having from five to seven separate lens elements inside and manufactured to the same quality standards as first-class lenses.

Canon currently offers two teleconverters of their own, which match the quality and characteristics of the EOS lenses. The first one, the EF 2X E multiplies the focal length of the lens mounted on it by two times. The second one, the EF 1.4X E multiplies the focal length of the lens by 1.4 times.

Tilt-Shift Lenses

Of all the lenses in the EF system, surely the most unusual are the trio of Tilt-Shift lenses, the TS-E 24mm f/3.5L, TS-E 45mm f/2.8, and TS-E 90mm f/2.8. These lenses replicate two of the most

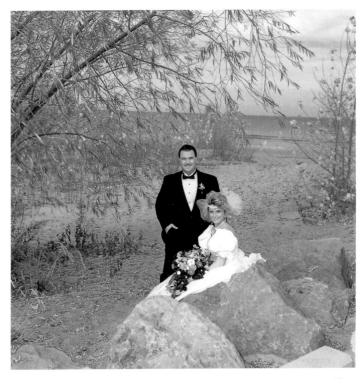

This outdoor portrait was shot without filtration (left). A diffusion filter was used in this view (right). Notice how the filter affects not only the ...

valuable movements of a large-format view camera, namely tilting and shifting. While shifting is available in a few non-Canon perspective control lenses, tilting is unique to the TS-E series. Books have been written about these complex functions, but I will try only to sketch the basic outlines.

Because the plane of focus of ordinary lenses is parallel to the film, maximum depth of field is available for subjects that are parallel to the film as well. A good example might be the wall of a building, all of which is parallel to you, and all of which you can easily render sharply on film. But what if the camera is angled at 45 degrees to that wall, in order to make a more interesting pic-

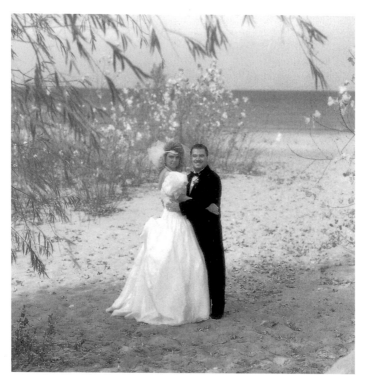

... sharpness but also the contrast for an overall softer, pleasing effect.
Photo: Scott Augustine/Mayfair Two Studio

ture? Depth of field may be inadequate to render it all sharply, no matter how small the lens aperture. A tilt lens, however, lets you adjust the plane of focus so it is parallel to the subject rather than parallel to the film. If the lens is tilted to the same angle as the wall, the entire wall will be rendered sharply, even if a wide aperture is used. Conversely, if you tilt the lens so that it is perpendicular to the wall, depth of field will be radically reduced, dramatically highlighting the extremely narrow plane of sharpness.

Shifting is an elegant way to "correct" a subject's converging lines so they look parallel in the image. When using a conventional lens to photograph a building, for example, you often have

to tilt the camera backward to include the whole structure. The walls seem to converge, giving the building an unpleasant "falling back" appearance. With a TS-E lens, you can keep the camera parallel to the building and shift the optical axis of the lens upward instead. It is as if you had moved the entire camera far higher, taking in the whole building without distorting its geometric relationships. In order to preserve image quality when shifting, TS-E lenses are designed to project a much larger than usual image on film.

Needless to say, tilting and shifting are best done with the lens on a tripod-mounted camera. In order to accommodate the complex gearing needed for these movements, TS-E lenses offer only manual control of focusing and lens diaphragm. Since they are unlikely to be used for quick shooting, this is not a significant drawback. The 24mm "L" lens has an aspherical element and a floating element as well. The 45mm lens offers internal focusing, and all three have non-rotating front elements for optimum use with filters.

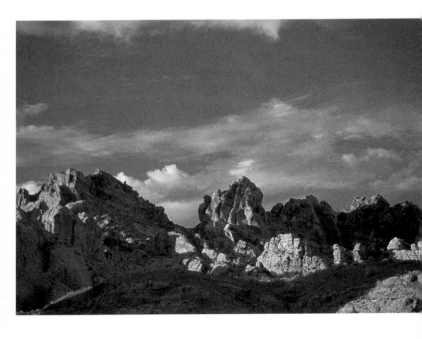

Other Accessories

The Grip GR70 is a grip extension that attaches to the tripod socket. An adjustable hand strap makes the Elan/100 easier to hold and handle, particularly with telephoto lenses.

With the Wireless Remote Controller RC-1, you can operate the Elan/100 at distances up to 16 feet. The unit can be set for either instant shutter release or for a two-second delay. The RC-1 can also be used to activate the camera's mirror lock and bulb (long exposure) functions.

The Dioptric Adjustment Lens E is available in ten types, from +3 to -4 diopters, to provide near- and far-sighted photographers a clear viewfinder image without eyeglasses. If you prefer using glasses, the Eyecup EB or the deeper Eyepiece Extender EP-EX15 makes viewing more comfortable. Other eyepiece accessories include the Right Angle Finder B, and the Magnifier S for critical manual focusing.

For information about Canon flash units and accessories, please refer to the Flash section of this book. The optional Bar Code Reader is discussed in the "Special Functions" section.

Filters

Filters can be used to enhance or correct the way an image will appear on film. Purchasing even a few filters and using them properly can make a big difference in the final outcome of your photography. Experimenting with the many special effect filters available from manufacturers such as Cokin® will add hours of enjoyment and can produce many interesting and unusual photos.

Canon offers an extensive line of filters. These include screw-in glass filters, in sizes from 52mm to 77mm, and gelatin filters in the same range to fit an appropriate holder. Drop-in 48mm filters are available for lenses with a built-in filter slot.

The deep sky, white clouds and striking contrast in the rocks are examples of how an image can be enhanced by the use of a polarizing filter. Make certain that you purchase a circular polarizer and not a linear polarizer which would interfere with the EOS Elan/100's autofocus system. Photo: Bob Shell

General Purpose Filters

These filters are effective with either color or black-and-white films.

Polarizing filters: Polarizing filters can eliminate distracting reflections on non-metallic surfaces such as water, glass, polished stone, wood or varnished surfaces, as well as dyed surfaces. Also, grasses, plants and (in particular in southern countries) plants with leather-like leaves not only reflect visible light but also UV radiation which the film receives as blue light. In these situations, polarizing filters offer warm, spring-like green colors. The effect is strongest at an angle between 30 and 40 degrees relative to the reflecting surface. Greater focal lengths enhance this effect significantly. Distance views are improved in particular. The result may be controlled visibly in the viewfinder.

Only circular polarizing filters can be used with the Elan/100's autofocus system. Canon offers these filters in four different sizes (48, 52, 58 and 72mm). Unfortunately, the use of a polarizing filter is complicated by using zoom lenses because many have a front ring which rotates when the lens focuses. Therefore, it is recommended you focus first and then adjust the polarizer.

Neutral density filters: Neutral density or ND filters are used to block a portion of the light from entering the lens. This gives the photographer greater control over exposure. For instance, a large aperture or slow shutter speed can be used in bright sunlight with fast film. Theoretically, an ND filter absorbs all wavelengths of light equally so the color-balance of a photograph is not affected. In reality, they may give an image a slightly cool appearance.

The graduated versions of these filters are a "must" for landscape photographers in order to reduce the contrast between the sky and land. Water, sky, snow and sand or other light-colored surfaces can also be darkened with these filters. Similar filters, available in various shades of orange, red, and blue, are used to darken as well as tint colorless subjects such as sky. Cokin makes many different filters of this type.

The use of a Cokin® Warm Color Diffusion filter gave the subjects a ⇨ **healthy glow and added a romantic, dreamlike quality to this summer garden portrait. Photo: Scott Augustine/Mayfair Two Studio**

Skylight filter: Protects against UV radiation in the mountains and at the ocean and adds a slight overall warming effect to the photo. Like all filters, it should be used only in conjunction with a lens hood to prevent flare caused by light reflected from the two surfaces of the filter. Skylight filters are often left on the lens at all times, which is not true with other filters, as a safeguard against scratching the front element of the lens.

Soft-focus filters: Although soft-focus filters are most commonly used for portraiture, the appealing, dream-like quality they create can enhance many subjects. A variation of the soft-focus filter is the center spot filter with a clear center with diffused edges. The amount of diffusion produced by a soft-focus filter varies greatly from just smoothing a subject's skin to producing a hazy image with little detail. There are literally hundreds of styles available.

Filters for Black-and-White Photography
Yellow filter: This filter is used to produce a tonally correct sky. It is a must to obtain correct tones in sunny snowscapes.

Green filter: This enhances the gray-scale differentiation of greens, and darkens red, blue and magenta. It is useful at the seaside to reproduce the sky in the correct gray-tone and make brown or tan skin appear even darker. Freckles become more noticeable in portraits.

Orange filter: This filter darkens blues. White clouds stand out vividly against the sky. Views of distant objects are enhanced. Its effect may be increased dramatically by adding a polarizing filter.

Red filters: With this filter, blue sky turns deep black, clouds are offset distinctly and everything red will become considerably lighter. The same applies here as for all other black and white filters, subjects of the same color as the filter become lighter, the complementary-color subjects becomes darker.

Experiment! Set your camera on a steady surface or a tripod and try a long exposure. The Elan/100 can set a timed shutter speed of up to 30 seconds. For longer exposure times, the "Bulb" setting allows the photographer to hold the shutter open for any length of time.
Photo Paul Comon

Getting Good Results

The best way to get to know your camera is to spend as much time as possible taking photographs. As you become more comfortable using the camera, you will find that operations which seemed complex when you first read about them are actually simple and direct. As you use your EOS Elan/100 more, you'll be more familiar with the camera controls and better able to fully utilize the camera's many capabilities. After all, film is still the most affordable aspect of photography, so don't be afraid to experiment. It will be money well spent.

Selecting the Right Film

Amateur photographers can be careless when it comes to choosing film. They routinely pick one based on price or availability rather than manufacturer, type, speed, and characteristics. This is really a shame since a great deal of time, energy and effort are expended to capture some decent images on that film. Subjects and shooting situations will vary dramatically and a film which is perfect for depicting one scene may not be the best choice for another.

So give some thought to the film you're loading in your camera. At the very least, decide whether you'd like slides, desirable for their brilliance and three-dimensional look when projected. Or do you prefer color prints? Or would black-and-white film be preferable for that visit to a reconstructed 1860's village? And do you plan to use flash, or would a film with a higher ISO be more appropriate, allowing you to shoot with available light?

When taking a photograph, think of how you want to portray your subject or what feelings you want to evoke from the viewer. To present a calm and peaceful mood, the photographer leads you down a brick path to an empty table in a quiet cafe, shaded from the sun and surrounded by lush foliage. Photo: Bob Shell

Film Speed

A film's sensitivity to light is often referred to as the film's "speed." More sensitive films require less light for proper exposure and have higher ISO ratings. The less light the film requires, the "faster" the film is considered to be. However, the term "fast film" applies to those with an ISO of 400 or higher. "Slower" films with less sensitivity have a lower ISO number and require more light for proper exposure. "Slow films" are generally those with an ISO of less than 100.

This would seem to argue for using a fast film all the time, but there are trade-offs. On a sunny day, there may be too much light to use very fast films. Also, as film speed increases, so does the film's grain size and it becomes more apparent as an image is enlarged. Color quality and saturation decrease as film speed increases. If bright, vibrant, sharp images are desired, use slower speed films. However, slow films have drawbacks also. They present more constraints on shutter speed and aperture selection. Using longer shutter speeds will allow more light to hit the film, but then a tripod is usually needed to prevent camera shake. Generally a medium speed film will be adequately sensitive for most photography, and will yield very high-quality results. As a general rule, use ISO 100 film outdoors in bright sun and ISO 200 and 400 on overcast days or indoors with flash.

Black-and-White Films

Almost every manufacturer of film makes some type of black-and-white film, and in many cases they make several varieties. In spite of the great diversity of brands and names, there are really only two sorts of black-and-white films available today. These are the traditional silver-based films and chromogenic film (currently made only by Ilford).

In the standard types of silver-based films, the light sensitive agents in the film emulsion are silver compounds. After the full processing cycle, the image retained in the film is made up of tiny

Knowing that this portrait would be made into 8x10 inch and 11x14 ⇨ **inch enlargements, the photographer chose a slow-speed, black-and-white film for its sharpness and fine grain. The photo was taken in a studio with high-power flash units providing plenty of light, so the film's low sensitivity was not a problem. Photo: Bob Shell**

grains of metallic silver. Such emulsions were the first type of photographic material which produced a negative image from a positive one. The Daguerreotype, the very first process, made one-of-a-kind positive images which could not easily be reproduced. Today we benefit from films in which the sensitivity of the silver compounds has been greatly increased, the color sensitivity has been expanded to approximate the visible spectrum, and the size of the fully processed silver grains greatly reduced.

The chromogenic black-and-white films currently have only one representative, Ilford's XP-2. This film starts out much the same as a standard black and white film, but in addition it has color dye couplers linked-up with the light sensitive silver compounds in the emulsion. After exposure, the film is processed to produce metallic silver grains. Then the dye couplers produce clouds of dye around these grains, and developed and undeveloped silver is completely removed from the film. Thus a processed negative on XP-2 contains no silver at all; the image is made entirely of tiny dye clouds. The benefit of the chromogenic film is that it is pro-cessed using C-41 (standard color negative) chemistry. This makes it much more convenient to find a photofinisher. For traditional black-and-white films, photographers usually process and print their own pictures.

Color Films
Modern color films come in two basic types; those in which the developed film yields a negative image, and those in which it yields a positive image. Color negative films are used to produce prints as the end result. The positive images produced by transpa-rency films are called slides or chromes and are usually the end result themselves. Prints can also be made from slides, however, it is a more involved process.

Color Transparency Film
Color transparency films are generally distinguished from other films by having the suffix "chrome" as part of their names, as in Fujichrome, Agfachrome, Kodachrome, Ektachrome, etc. The films mentioned are registered trademarks of Fuji, Agfa, and Eastman Kodak respectively. Today, there are three types of color transpa-rency films generally available, distinguished by how they are pro-cessed.

Kodachrome films from Kodak are direct descendants of the first commercially successful color film, the original Kodachrome. Kodachrome films are unique in that they are essentially multilayer black and white films. Through an extremely complex developing process, colored dyes are added sequentially to the layers of the emulsion to build up the full-color image. Because of the difficulties involved, Kodachrome processing is being done by fewer and fewer labs. In spite of the inconvenience of finding processing, Kodachrome film is still the choice of many professionals for its color reproduction and archival qualities.

All other current color transparency films have dyes added as color couplers during the manufacturing process. Chemicals in the developing process react with the couplers to produce the dyes, giving these films their name, chromogenic (color generating). Almost all films in this category today are developed using the E-6 process pioneered by Kodak or its equivalent by Fuji, Agfa or others. Except for Kodachrome, the transparency films you are likely to encounter today will be E-6 compatible.

Using color transparency film: As a general rule, color transparency films have a relatively limited exposure range. This means they are very sensitive to incorrect exposure. For professional results, this range is limited to less than one stop of over- or underexposure. Properly exposing film with such a limited range requires a very precise exposure meter and careful metering technique. The Elan/100's metering system is very accurate and can be trusted in most situations. In working with transparency films, the Partial Metering mode can be a very valuable tool, so take the time to learn to use it properly.

Generally, color transparency films will tolerate underexposure better than overexposure, and many photographers habitually underexpose the film by as much as 1/3 to 1/2 stop. This darkens the image just enough to produce more saturated colors. The photographer should be very familiar with exposure techniques and the film being used for the best results.

Recently there has been somewhat of a revival in color transparency films, with some wonderful new films coming along from most of the major manufacturers. It is fun to experiment with different slide films from different manufacturers; each has its own characteristics and color rendition. However, most amateur

photographers today tend to use color print film exclusively. They want a final product which can be easily duplicated and viewed without the hassle of setting up a slide projector.

Color Negative Film

Color print films are readily available in speeds ranging from ISO 25 up to ISO 3200. The same rules apply as with any other film, the lower the ISO number the finer the grain and the greater the resolving power to render fine detail. Generally speaking, the lower the ISO, the higher the contrast. Also, different color films will reproduce color differently. There are a variety of "recipes" for film, and every manufacturer has its own. Some films are designed with a warmer color-balance to make skin-tones look good. Others make bright colors look more vibrant. In addition to film type, processing has a huge effect on how the final image looks. It is highly recommended you choose a lab that employs knowledgeable people to answer questions you may have about the quality of your photographs.

Color print films also come in two versions, amateur and professional. Do not be confused by this, the professional film does not necessarily provide better quality. It is simply more carefully matched to the needs of the professional, and should be stored in refrigeration to hold it at its peak color balance prior to exposure. Professional color films are issued on the assumption that the film will be exposed within a short time of removal from refrigeration, and then processed promptly. If you are the type who leaves film in the camera for months at a time, you probably should not use professional films.

Color Balance

Practically all color films you will encounter are designed for use with daylight or electronic flash, which is color-balanced to approximate daylight. Using these films under other lighting conditions will produce photographs with unnatural color rendition, even though the light source may appear "normal" to the human

When photographing subjects with intricate details, use a slow film, such as ISO 50, for its fine grain structure. Photo: Bob Shell

Photographs are excellent mementos of an enjoyable experience. For many photographers, spending time in the darkroom making prints is like reliving a vacation. Photo: Paul Comon

eye. Common fluorescent lighting gives photos a greenish cast. Ordinary household lighting is usually tungsten, and produces a warm, golden-yellow tint on daylight film. These colored tones can be used to advantage in certain situations, for example night shots benefit from the colors created by different artificial light sources. Also, artificial light sources can be used to great effect in combination with natural light or electronic flash.

Film Processing
When traveling outside the United States, you may encounter some unusual films. Remember that processing may not be standard and it may be impossible to have the films processed at home. Film manufacturers everywhere are adopting the standard E-6 process for their color slide film and the C-41 process for their color

negative film, but until this transition is complete be wary of unfamiliar films. This is unlikely to be a problem with black-and-white films, since they are reasonably standard no matter where they are made, but color films are another matter entirely. Because you can't know the quality and storage conditions of films bought during travel, it is far better to bring all the film you'll need with you and return with it for processing.

Framing and Composition

The EOS Elan/100 will produce near-perfect exposures. The photographer, however, must still select and frame the subject. First, practice learning to "see" or visualize an image in order to be able to select an interesting part of a subject in the perceived environment. The human eye is most effective when looking at objects with a viewing angle of 46 degrees but it is also capable of focusing at a much smaller angle. Because sharpness is also concentrated in the range of greatest interest, this can be called "selective" perception. The framed part of any image should show what is most important. This effect is most easily achieved by omitting extraneous objects. Shooting the subject up-close or adjusting a zoom lens to crop tightly on a subject are ways to accomplish this.

A 50mm lens (or a zoom lens set at 50mm) "sees" like the human eye. In other words, the angle of view is approximately the same. Pictures shot at this focal length are perceived as "normal." With a focal length less than 50mm, the lens' angle of view is increased in proportion to the reduced focal length. An even greater image angle due to an additional reduction of the focal length will result in a super wide-angle range (from 28 to 20mm with EOS lenses). If the camera is held properly, with the horizon through the center, there will be no problems with perspective except the feeling that the image narrows dramatically toward the horizon.

The reverse approach is taken when the lens focal length is greater than 50mm. The viewing angle becomes smaller and the subject becomes larger. As a result, pictures taken with a focal length range of 50mm to 100mm will still be perceived as normal because they offer the viewer a very reduced, framed image.

This approximates the selective perception of the human eye. Lenses ranging from 100 to 200mm produce a somewhat "telescopic" effect. Focal lengths of more than 300mm are usually considered to be super-telephoto.

Emphasizing the Subject
The main subject can be emphasized by framing but a few aesthetic basics should be considered. The simplest method is to have the subject fill the frame. This is may be done with almost any subject.

Should full-size framing not be attainable or desired, lighting may give the picture appealing qualities. Emphasizing the main subject by illumination is the simplest method. A single spotlight directed at a subject forces the viewer to look at the resulting highlight. The same effect may also be provided by nature—a light beam breaking through a cloud lighting up an alleyway or a forest path. Larger, contrasting areas of light and dark, such as a view through a window or a passage through a gate, may add emphasis to a view.

The Use of Color
Color, too, will influence image composition. Contrasting colors create visible differences, a person dressed in red on a green meadow will certainly stand out. Certain colors such as yellow are perceived by the human eye as particularly brilliant while deeper tones such as dark-blue or violet are noticed less. In general, warm colors will move toward the foreground of a picture while cold colors will recede. This is particularly true for blue, a cool color. Often this fact is not given enough consideration when small subjects or still lifes are photographed. Light areas are more conspicuous than dark areas; therefore, light-colored spots in the background will draw the viewer's eyes.

Spot lighting on the face gives a dramatic look to this fashion shot and draws the observer into the quiet mood of the photograph. Photo: Bob Shell

Selective Focus

A sharp image is perceived to move forward and is noticed more readily than one which is out of focus. Consequently, a photographic "play" of selective focus is particularly impressive. Sharp foreground detail with a blurred background is always appealing. A portrait with an out-of-focus background allows the eye to linger on the model. Selective focus is one of the secrets of good photography.

Graphic Form

A composition that is understood by the viewer will produce an interesting picture. A graphic image composition can enhance such an interpretation. Those who have an opportunity to view thousands of pictures in a high-volume photographic laboratory frequently get a strange impression when looking at pictures. Most appear as if the photographer had just discovered the subject and shot it in that exact situation. This is not usually the best possible shot. The interesting features of the scene have been presented in a photographically ineffective format because the photographer neglected a number of considerations. First, there is the difference in the way the camera and the eye view a subject. The human eye's perception is selective. Even if the eye's interest in a subject. is triggered by optical form or color stimuli, it will only register one or the other. The surrounding area (to the right and left, to the front and back) of the selected subject will not be acknowledged voluntarily. Selective perception is how photos end up with trees growing out of people's heads and too many uninteresting small subjects next to the main subject. The camera is just a recording tool that indiscriminately picks up everything it sees. Without a critical eye behind it, it records anything within its viewing angle.

When composing potential photographs it is helpful to ask why an image is appealing in the first place. Some scenes are better left unphotographed. When an interesting subject is found, compositional elements should be considered. Assuming the subject

Using an interesting angle of view can turn a mundane photo into an award winner. Photo: Bob Shell

is a door, an upright format may be chosen where the door frame is parallel to the image edge. In this case the camera is best located directly in front of the subject so that the subject plane and the film plane are parallel.

Perspective

Regardless of whether lenses or focal length settings are changed, the perspective of a subject is the same for all shots provided the same camera position is used for taking pictures. Perspective changes only when the photographer changes location—the relationship between subject and background is altered. However, because questions inevitably arise regarding dynamic wide angle and space-constricting tele-perspective, here are a few comments concerning the concepts of perspective and distortion.

The vertical lines of a skyscraper photographed with the camera held at an oblique angle are viewed as falling lines and distorted. The lines of railroad tracks converging in the distance, however, are accepted as normal even though both phenomena follow the same laws of linear perspective. In order to obtain true-to-life images following the law of linear perspective, artists used the precursor of the photographic apparatus, the camera obscura.

A truly distortion-free image can be achieved only when photographing a two-dimensional object. Three-dimensional subjects require a surface which is plane relative to the camera. In both cases the surface to be reproduced must be exactly parallel to the film plane; otherwise trapezoidal or rhomboidal distortions occur. Of course, this also applies to a circle. In perspective reproduction it appears as an ellipse. The circle retains its circular form only when it is parallel to the film plane. Unless this parallel arrangement exists, the subject is distorted. Any miniaturization, reduction in length or convergence of parallel lines constitutes a perspective distortion. Only the photographer's or viewer's perception will differentiate what is considered natural (correct perspective) or abnormal (distorted).

City scenes like this view of a New Orleans street are often improved by shooting late in the day when sunlight is angled low, giving a warm and inviting feeling. Photo: Bob Shell

By selecting the focal length and the camera-to-subject distance carefully, the photographer can modify the degree of distortion. The degree of distortion may be controlled and, therefore, this image composition technique is employed deliberately by creative photographers to compress image information and to increase the emotional content of their photographs.

When as many pictures as possible exhibiting different characteristics are to be taken of a subject it is easiest to just change the focal length and the shooting distance. Cutting the shooting distance as well as the focal length in half makes subjects appear in a steep perspective. The size in the foreground is emphasized and the vanishing lines appear to converge much sooner in the background. The effect is the opposite when both shooting distance and focal length are doubled. The foreground and background appear compressed. This effect may be achieved rather easily with a zoom lens; however, the shooting distance must be changed at the same time.

One effective utilization of perspective (provided the camera is held vertically) hinges on the realization that not only parallel lines are reproduced based on the laws of linear perspective. For example, many photographers will reach for a wide-angle lens when the busy life in a narrow alleyway is the subject. In most cases the result is boring because the wide-angle lens changes the relationship between the foreground and the background so that the close-up range is reproduced relatively large and the background extremely small. In this situation the photographer who wants to convey the mood and atmosphere of an over-crowded alleyway will step back farther and use a telephoto setting. The "space-constricting effect" (the recognizable linear perspective) suddenly fills the same alleyway with lots of people milling around. Each lens takes advantage of typical viewing habits which are affected greatly by the relationship between the shooting distance and between the subject and the background.

10 Tips for Better Travel Pictures

1. Make plans and check equipment, especially batteries, in advance.

2. Try to shoot evocative rather than just illustrative pictures. Do not confine yourself to strict documentation. Try to capture moods.

3. Learn to observe. Often patience is more important than any staging. Hold a slide frame in front of your eye to learn to see photographically.

4. Move as close as possible to the subject.

5. Instead of capturing extensive exposure series using the same framing, lift the subject out by taking shots from different perspectives.

6. Do not just change the focal length. Change the distance and hence the perspective. Try to take photographs from the perspective of a frog or bird.

7. Force yourself to see image compositions and graphic relationships consciously. Only those who master the rules of classic image composition will be able to break them.

8. Always aspire for the best optical and technical quality in your pictures. To achieve this, examine the viewfinder image carefully. Use a tripod or monopod, polarization filters and fill flash.

9. Take pictures in extreme lighting and weather situations and at unconventional times of the day such as early in the morning or at dusk.

10. Always ask permission before taking pictures of people.

This exotic-looking travel photo was (appropriately) taken outside of the Canon factory. Photo: Bob Shell

Notes

Notes